CONTENTS

4
6
8
12
16
20
22
24
26
28
30
32
34
36
38
42
46
50
54
58
60
64

PORTRAIT OF AN ARTIST JOHN BLOCKLEY R/

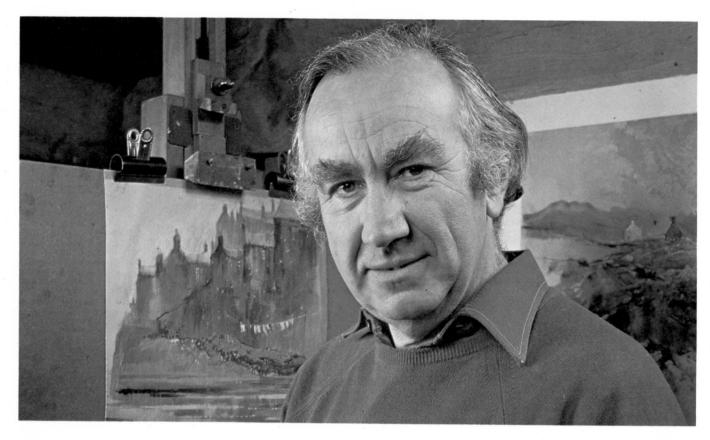

John Blockley was born in Knighton, Shropshire, on the Welsh border, and for some years lived and worked in the north of England.

He now lives in Lower Swell, a small village in the Cotswolds, where he has established a painting centre, running courses which attract students from all parts of this country and abroad. The painting centre is based in his studio, which he converted from a large stone barn dating back to the sixteenth century. At the time of writing, he is also planning the conversion of another sixteenth-century building in nearby Stow-on-the-Wold, to create a gallery displaying his own work, and that of his close associates.

Blockley sums up his attitude to painting as a continuing exploration; always looking for new ideas and interpretations. His work is based on constant observations of everything around him. He is not interested in merely a photographic likeness of the subject; whether it is a land-scape, people or buildings. Nor is he concerned with distortion or contrived effects – his interest is in seeking out some special mood or quality of the subject, such as

light, surface textures of buildings, or patterns of rocks, the ground and tree trunks.

These interests have evolved through many years of painting landscapes throughout Britain. While living in the north, he painted mostly mountains, moors and industrial subjects. He frequently painted large landscapes, but also small, intimate studies of corner shops and shoppers with their baskets. He deliberately moved to the Cotswolds to work in a new environment, leaving an area where he was completely settled. He now paints the totally different architecture of mellow Cotswold buildings, woodlands and rolling landscapes of the upper wolds.

His work is widely sought and there is always a demand for his paintings in the few selected galleries where he exhibits. His paintings are in collections the world over.

John Blockley paints mostly in pastel and watercolours. In 1967 he was elected a Member of the Royal Institute of Painters in Watercolour, and in 1969 to the Pastel Society of Great Britain (of which he was made President in 1982). He exhibits annually with these societies at the Mall Gallery, London.

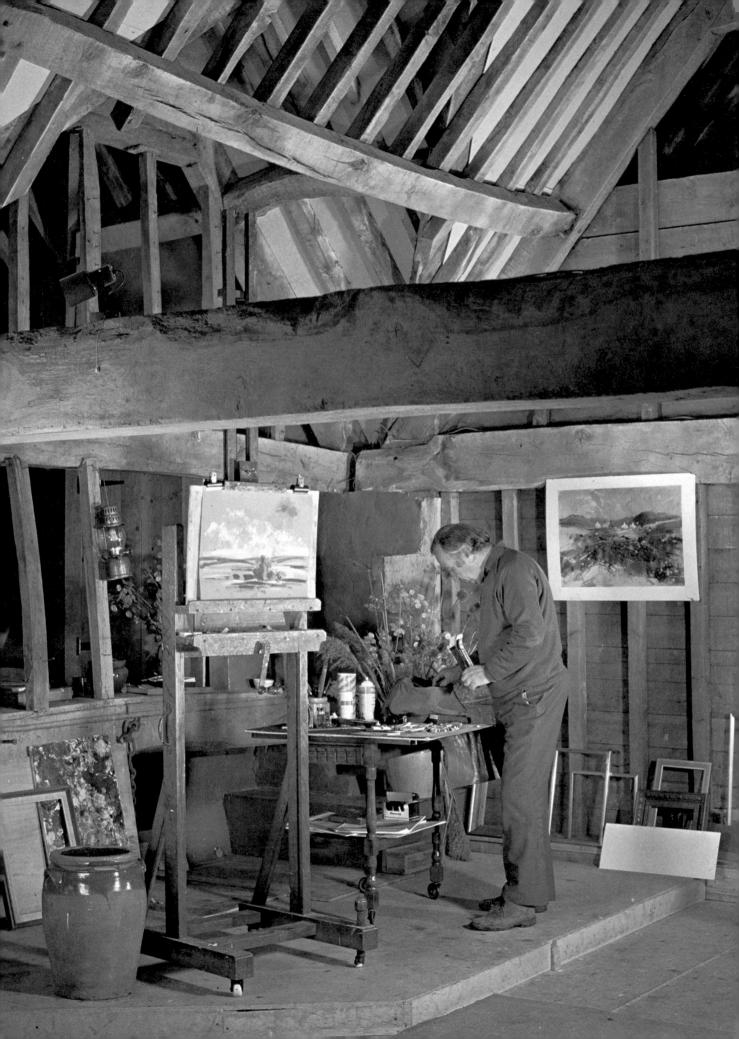

WHY USE PASTELS... AND WHAT ARE THEY?

Ravenglass, Cumbria

Why use pastels?

Pastel painting can be as colourful and vigorous as any method of painting. It is a dry medium, and its powdery surface increases the refraction of light, so pastel paintings emit an intensity of colour unchallenged by any other medium. Because it is dry, there are no frustrations of waiting for the paint or paper to dry. It is dry paint – we pick up the pastel and apply colour directly to the painting surface. It can outlast oil paint because it has no oil or varnish to yellow and crack with age.

In addition to these technical advantages, pastel is an exciting medium. Most people are attracted to the paintings of ballet dancers by Edgar Degas, but probably only a few realize that many of the paintings were made with pastels. Degas, probably more than any other artist, exploited the special properties of pastels. He produced exciting paintings that seem to vibrate with colour. His painting Dancers in Blue was painted in 1890 and is typical of his way of handling pastels. It shows a group of dancers dressed in blue and set against a rich tapestry-like back-

ground of brilliant splashes of orange and red.

Because pastel is dry, Degas was able to apply colour over previous colour, with short, quick strokes, dashes and dots of pastel, so the colours underneath showed through. He painted racehorses, full of movement, rippling grass and reflecting light. This movement of colour and light is apparent in all his paintings, whether they are figures, interiors, landscapes, beach scenes or big skies. To me, Degas demonstrates more than anyone the possibilities of the pastel medium.

Pastel painting, in its present form, dates back to the eighteenth century, although chalk drawings were made on cave walls in prehistoric times. Pastel paintings more than 200 years old are as bright and fresh today as they were when they were painted. Pastels require no more protective treatment than that given to any other type of painting. The best way is to frame a pastel under glass, with a surrounding mount or narrow fillet between the pastel surface and the glass, which prevents the glass rubbing against the picture.

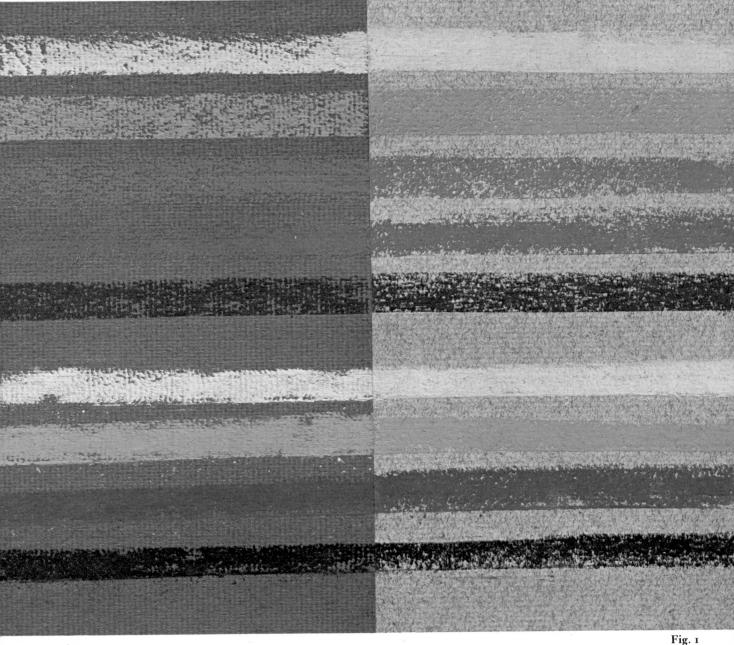

What are pastels?

Many people do not realize that the pigments in pastels are exactly the same as those used for oil and watercolour paints; the difference lies in the manufacturing process. Oil paints are made by mixing finely-ground pigment with oil, watercolours are made by mixing pigment with gum, and pastels by mixing pigment with chalk and water to make a stiff paste. After checking the colour, and adjusting it if necessary with extra pigment, the paste is pounded to remove air, and formed into long, round strips, which are cut into short lengths of pastels. After drying, the pastels are individually labelled and carefully boxed to avoid damage in transit.

Most manufacturers incorporate a binding material to hold the powder together in short sticks. The quantity of

binder in the mixture can affect the strength of the finished product and the quality of the pastel's mark. Rowney are one of the few manufacturers with a process of making pastels without a binder, which accounts for the durability and softness of their pastels.

The strength of the colour in a pastel is determined by the amount of chalk mixed with the pigment. A lot of chalk will produce a pale tint, and a little chalk will give a dark tint, so there is a range of tints within every colour. Rowney pastels are graded from Tint o for the palest up to Tint 8 for the darkest. The top range in fig. 1 is Burnt Sienna, starting with Tint o at the top, followed by Tints, 2, 4, 6 and 8. The other range shows Tints 0, 2, 4 and 6 of Purple Grey. I drew these tints across two shades of grey paper to show how different tints appear on different tints of paper.

WHAT EQUIPMENT DO YOU NEED?

I always use Rowney pastels; they are consistently good and I like their velvety texture. Throughout the book I have referred to Rowney's range of colours and tint numbers. The range consists of up to six tints of 52 colours, making a total of more than 200 pastels.

Pastels

I am often asked how many pastels are necessary to produce satisfactory paintings. I think it is helpful to have a generous assortment because it is very frustrating to find while you are painting that you haven't got quite the right tint. You would have to compromise and use the nearest tint you have, or adjust some of the colours you had already used on the painting. We can mix a required tint to some extent by laying one colour on top of another. For example, we can make a pink tint by covering red with white pastel, but this is likely to turn out to be a crude solution.

Pastels are usually stocked in the shops in two ways – as

- A BOX 144 PASTELS ASSORTED
- B BOX 36 PASTELS LANDSCAPE
- C BOX 24 PASTELS LANDSCAPE
- D BOX 12 PASTELS PORTRAIT
- E ABROSOL FIXATIVE -LARGE
- F BOTTLE FIXATIVE LARGE
- 6 AEROSOL FIXATIVE SMALL
- H BOTTLE FIXATIVE SMALL
- I HOG AND SABLE BRUSHES
- J SPRAY DIFFUSER
- K DRAWING INK
- L TUBES OF WATERCOLOUR
- M PASTEL PACKAGING CONTAINER
- N PUTTY RUBBER
- O WILLOW CHARCOAL
- P PASTEL PAPERS
- Q RANDOM PASTELS ON WORK BENCH
- R PENCILS
- S PAD OF ASSORTED PASTEL PAPER

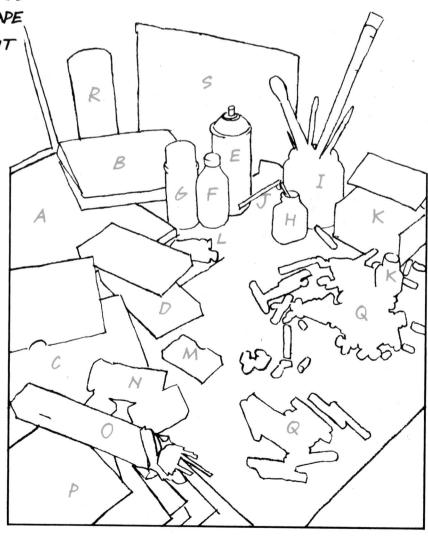

boxed selections or individual pastels. Boxes come in varying sizes, containing as few as 12 pastels or more than 100. There are also selections available specially for landscape or portrait painting.

Individual pastels are usually displayed in trays, so you can see a large number of tints at a glance. They are a picture in themselves! You should select your pastels from the trays by the appearance of the colours, not by their names. If you should need to order some by post, the names will give you a good idea of colour subtleties, such as Blue Green, Yellow Green, Olive Green, Purple Grey and Purple Brown.

If you are just starting to paint with pastels, you will probably wish to begin with a modest selection. A basic selection should include: Yellow Ochre, Coeruleum, Cadmium Red, Red Grey, Purple Grey, Green Grey, Warm Grey, Sap Green, Burnt Umber and Indigo. You will need a light, middle and dark tint of each colour. Remember that the lightest tint you can get is Tint o and the darkest is Tint 8.

When you buy your pastels, each piece will be wrapped in a paper band bearing the colour and tint number. Most of your painting will involve dragging the side of the pastel over the paper, so you need to remove the pastel from its wrapping paper, and break off a piece with which to work. It is a good idea to make a colour reference chart by rubbing each new pastel on to a sheet of paper and writing the colour name and tint alongside it. Otherwise, you will need to replace each piece of pastel in its wrapper so you can identify it when you need to reorder.

Storing pastels

You can buy special boxes which include a plastic corrugated tray to hold the pastels. These are useful for storage purposes and you should form the habit of always returning each pastel to its place after use. You could also mark each corrugation with the details of its colour. Some painters make their own containers by lining a shallow box with corrugated cardboard.

Another method is to have a small tin box for each colour; one for your greens, another for yellows and so on. By keeping all tints of a colour in one box you are able to compare them quickly and select the particular colour and its shade. If you store different colours in a box, it is useful to fill the box with ground rice. This prevents them from rubbing against each other, and the slight abrasive quality of the rice will keep the pastels clean. The rice should be sifted away when you want to use the pastels, and replaced after use to perform its function again.

I must confess that I am untidy in this respect. I just leave my pastels lying on the table while I am working, all colours mixed together, but I am sure it is better to cultivate a more methodical way of working. I think it is a matter of temperament - I am too impatient to be tidy and work in long bursts of feverish activity. If I don't immediately recognize a pastel lying on the table because it has rubbed against others, I rub it on the nearest piece of cloth. This is usually my shirt. I do not recommend this practice. You should work out some way of storing pastels and establish a method of working so you can quickly identify the colours you want.

Handling pastel paintings

There is a lot of exaggerated fear about pastel paintings getting smudged. If they are treated carelessly the pastel will smudge, although the paintings I made for this book were handled many times before they appeared in print. It is sensible to take reasonable care of paintings and not slide one across the surface of another. They can easily be stored in a stack, each one separated by a piece of tissue or sheet of newspaper.

Loose pastel fragments are sometimes dislodged from a finished painting if it is bumped or dropped and I guard against this by spraying my paintings with a colourless fixative for pastels. This comes in both bottles and aerosol canisters. If too much spray is used, and the pastel becomes very wet, it will lose some of its brightness.

If I have used a thick build-up of pastel I often paste the finished work on a piece of mounting board. I place the painting face down on a clean table, brush synthetic wallpaper paste on the back of the paper, and leave it for ten minutes for it to soak in and to stretch the paper. Then I pick up the painting and turn it on to the mounting board so the right side faces up. I then cover it with a piece of newspaper and smooth the paper down with my hand, working out from the centre, taking care not to let the newspaper slip. The paste tends to soak through the paper and helps to fix the pastel. It is necessary to paste a sheet of paper to the back of the mounting board to prevent it from buckling as the painting dries.

I occasionally spray a fixative on the pastel while I am working on it. I can then apply another colour over the fixed pastel without disturbing it too much. I leave some of the first layer uncovered to give a broken, two-colour effect in the painting

Easels

I stand when I am working because I feel restricted if I try to work sitting down. I like to move about and be able to step back and look at the work instead of always having it under my nose. I walk about and return only half a minute later with a fresh eye and quickly recognize errors. I fasten my paper to a piece of stout hardboard with bulldog clips. It is sensible to put a few sheets of uncreased paper between the pastel paper and the board. This gives a pleasant, cushioned surface on which to work and also prevents imperfections in the board being transmitted to the pastel.

I usually support the board at eye level on an upright studio easel, but a portable sketching easel is equally suitable, and it can also be used for outdoor work. Another advantage of using an easel is that I like to have the painting

upright so I can stand away from it and work at arm's length for rendering broad sweeps of the pastel, and be able to step up close for detailed areas. Should the pastel crumble when I press too firmly on the painting surface, the particles fall and collect in the ledge on the easel, instead of adhering to the painting. An easel also reduces your chances of accidentally rubbing against the painting.

If you are less restless than me, or if you prefer to sit while working, a portable easel can easily be adjusted to a suitable height, or you can use a table easel which can be tilted to various angles, or you can lean the painting against a pile of books.

Supplies

I will discuss later the various papers I use, and I will show how I commence by drawing the subject, sometimes with a pencil, sometimes with ink or charcoal. You should get a bottle of black drawing ink, and some medium-grade sticks of charcoal. The charcoal gives a good black line of a texture and nature which is in sympathy with pastel painting. It is easily erased by using a putty rubber if you make mistakes – and we all do – and when you are satisfied

with the drawing you can flick the charcoal with a duster and leave a grey impression on which you can pastel.

The putty rubber is a soft rubber which can be kneaded into quite a fine point. It will erase pastel, cleanly, back to the paper. A painter's stiff hog brush is also useful for removing pastel, so mistakes in a painting can conveniently be erased without affecting the surface of the paper.

WHICH PAPER?

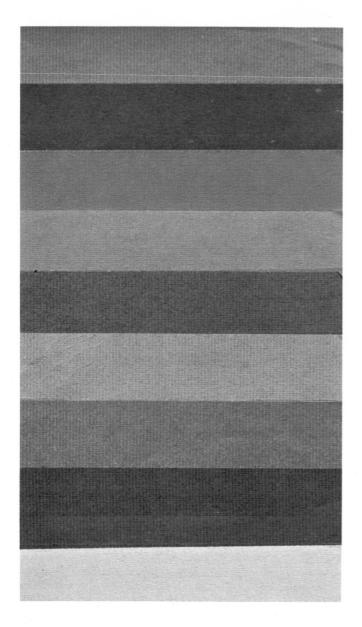

Fig. 2

Some pastel artists paint on hardboard, muslin covered board, canvas or even sandpaper, but most painters work on tinted papers made specially for pastel work. I use Italian Fabriano or Swedish Tumba Ingres papers. I like the subtle texture of these papers which enables me to drag pastel lightly over the surface, so the colour of the paper will show through and give an interesting broken-colour effect, or I can press the pastel firmly into the slight texture to obtain solid patches of colour. I would advise you to work on these Ingres papers, as the rougher surfaces of some papers can break up the layer of pastel too much. This gives a coarse, insensitive finish to a painting, but it

may help you achieve a desired effect.

I made some pastel strokes on the sample paper colours in fig. 2 to indicate that the paper grain can show through lightly applied pastel, or be covered by heavy pastel. Notice the difference in finish between the blue pastel on grey paper and the blue pastel on orange paper. The blue on grey is a subtle combination, whereas the blue on orange is an exciting, vibrant combination.

There are a number of such ways in which the colour of the paper can be chosen to give the required effect. A cool grey paper will give a pleasing background to a painting composed of pink and grey-green colours, and result in a

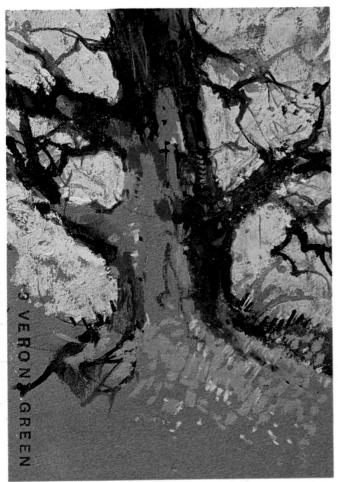

Fig. 3

restful, easy-to-look-at picture. On the other hand, brilliantly coloured pastels will make a striking picture when painted on brightly coloured or very dark papers.

The tone of the paper has considerable importance. Tone refers to the lightness or darkness of the paper. Dramatic effects, such as a brilliant light in the sky behind a dark mountain, can be obtained by using light pastels on dark paper.

I have discovered over the years that I can work better with a mid-tone paper, one not too light or dark. I use this mid-tone as a starting point against which I can judge the tone of colour I want. I determine if the pastel I am about to place on the paper should be lighter or darker than the paper. I find it easier to judge how light or dark a particular colour should be when working on mid-tone paper than I would working on a light or a dark paper. A mid-tone paper can also reduce the amount of work since a fair-sized part of it can be left uncovered. Although a mid-tone paper is a good starting point, dark paper can help if the subject is generally dark. As we work through this book we shall be constantly reminded of the part played by the colour and tone of the paper on which we are working.

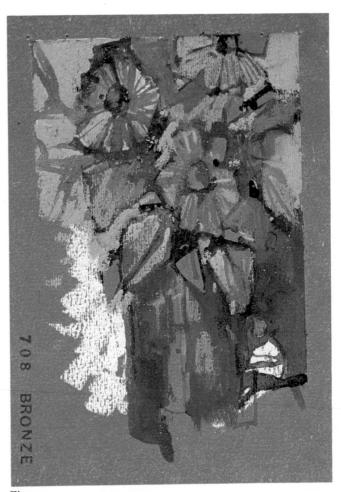

Fig. 4

Paper colour

The range of coloured paper gives us the opportunity of choosing a colour on which to work that will be sympathetic to the subject we are going to paint. For example, if the subject is mainly green we could use a green paper and leave parts of the paper uncovered, letting the paper do a lot of the work for us.

My tree painting (fig. 3) was done on Verona Green Fabriano paper and I left the paper uncovered for the foreground and the light parts of the trunk. It is only a small sketch painted on a sample swatch of paper, which I mention in passing to show that the smallest sketches can be effective by making the most of the paper colour with only a little pastel work. I relied mainly on three pastels: Coeruleum Tint o for the sky and Sepia Tints 5 and 8 for the dark parts of the tree.

The flower painting (fig. 4) was also made on Fabriano, this time Bronze. I used the paper colour for the flowers, with just a few touches of Lemon Yellow Tint 2 on the petals. The colour of the paper is allowed to show, uncovered, in other small parts of the painting. This is also a small sketch, rather stylized with simple, patterned shapes. The pastel medium is ideal for this type of treatment as it can be pressed on to the paper to make patterns of opaque

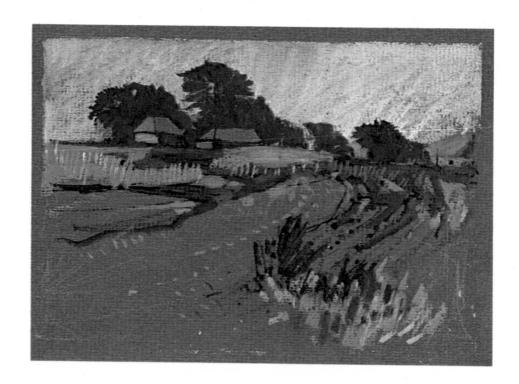

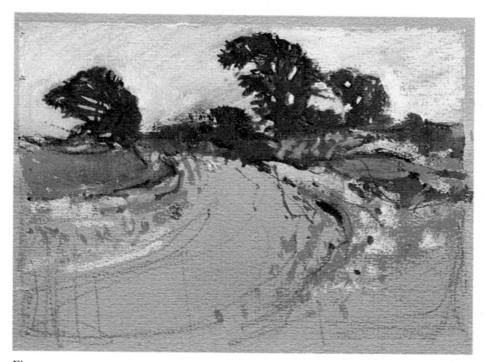

Fig. 5

colour, as in the blue background, or applied gently, as in the petals.

The simple landscape paintings in fig. 5 also leave large parts of the paper uncovered; the pastel work is confined almost to the sky and trees and leaves the bottom half of the paper uncovered. I have used the same pastels in both paintings, but on different colours of paper. I used Sienna Brown Fabriano paper for the top painting and Sand Fabriano Ingres paper for the other. The pastels used were

Coeruleum Tint o and Blue Grey Tint o for the skies and Olive Green Tint 2 for the grass. The trees are from Burnt Umber Tint 6.

You should experiment by painting some simple landscapes such as these on various colours of paper. At first use only a few colours. Try the same colours I used and then try a combination of your own choice. You should avoid bright colours for these first experiments. Keep the colours subtle so the colour of the paper is dominant.

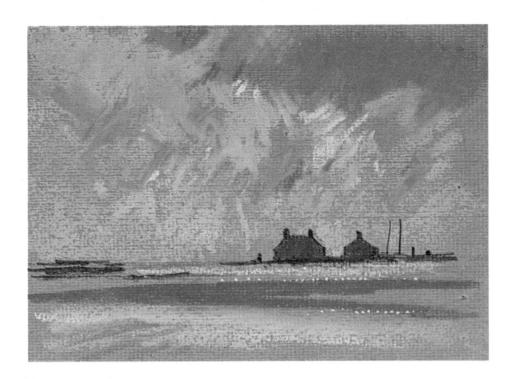

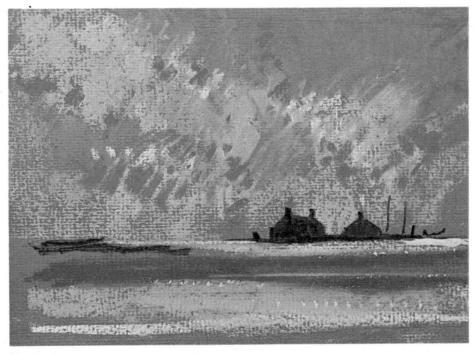

Fig. 6

Remember that the purpose of these experiments is to discover how much use you can make of paper colour.

The top estuary painting in fig. 6 was made on Fabriano Stone Grey paper and the second version on Fabriano Verona Grey. I used Coeruleum Tint o and Blue Grey Tints o and 2 for the sky and water. I used charcoal for the cottages and allowed the paper to show in both paintings.

Which paper would you have chosen? It really depends on the mood you wish to portray. The Stone Grey is sympathetic to the colour of the pastels and they combine to give a restful mood. Although I used the same pastels in both and applied them in the same way, the green paper is less sympathetic to the pastels, evoking a restless and vibrant mood.

HOW TO APPLY PASTEL

Fig. 10, opposite, shows some basic pastel strokes, made on Bronze Ingres Fabriano paper. The first two horizontal strokes at the top were made with a short piece of Red Grey Tint 2. I pressed the side of the pastel firmly on to the paper and dragged it sideways (see fig. 7, right). Notice how the texture of the paper breaks through the pastel. The band below is Red Grey Tint 0, pressed very firmly to fill the grain of the paper.

Alongside these colour bands are short, diagonal strokes of Red Grey Tint o pastel, applied openly to allow the colour of the paper to show between the strokes. I overlapped these with similar strokes of Red Grey Tint 2. Where the two pastels cross we get a rubbed combination of the two tints, and in other areas we see the original, unmodified strokes. By this process we can produce broken-colour effects, combined with bits of blended colour. We can extend this process to include additional tints of the same colour, or another colour.

I repeated the exercise using the same pastel tints, but using the end of the pastel to draw lines, rather than bands of colour (fig. 8). At the bottom of the paper I superimposed dots of Cobalt Blue Tint 2 over dots of Lizard Green Tint 1 (fig. 9). Alongside I combined the three processes; overlapping dots, lines and bands of colour.

You should experiment with these techniques. Use different combinations of colours and tints with various colours of paper. Also, vary the pressure of the pastel, so the colour of the paper sometimes shows through the pastel strokes. You will also discover how heavy pressure on a pastel stroke will affect the layer underneath. For example, heavily cross a line of grey with pink pastel and see how the pink will drag some of the grey with it.

This technique, called cross-hatching, was practised a great deal by Degas. His original paintings show remarkable results from overlaying pastel strokes of varying lengths: short strokes over longer strokes, hatched diagonally, vertically and horizontally, and combined with dots, sometimes crisp and sometimes blended. The flesh colours of his figures positively shimmer with light.

These methods of applying pastel are exciting to do and can produce vibrant effects. Go ahead and see what you can do. Don't paint pictures for this exercise – just draw lines and bands in all directions, overlap them, make big dots with heavy pressure, small dots with rapid stabs of the end of the pastel. Try to discover as many ways as you can of applying pastel.

Fig. 7

Fig. 8

Fig. 9

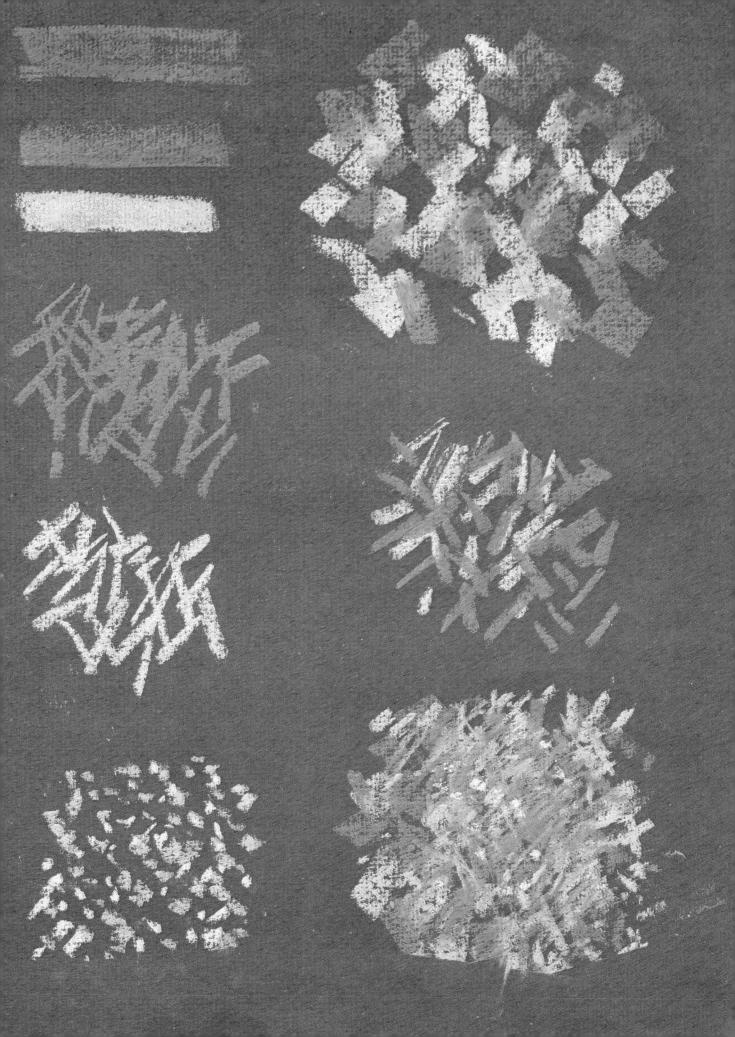

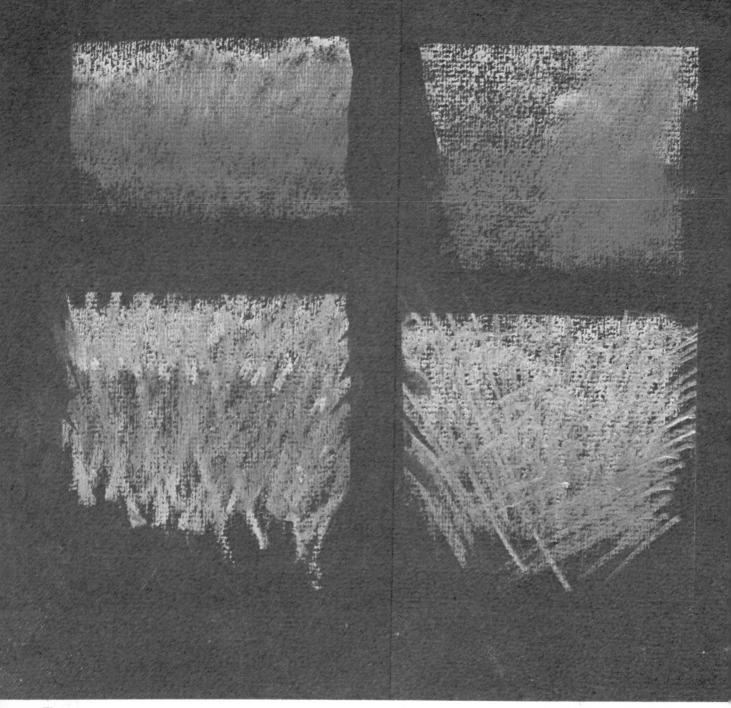

Fig. 11

Rubbing pastel

Highly-finished, smooth pastel work can be produced by rubbing with your finger to blend the colours. This can lead to an overworked, dull painting, where the pastel loses its freshness and bloom. This bloom is unique to the pastel medium and is caused by granules of pigment on the paper reflecting light. It seems a pity to destroy this by rubbing and smoothing the pastel into the paper grain, but this process is used by many painters and you must decide what sort of surface finish you like. I strongly recommend you keep the rubbing to a minimum until you have explored the possibilities of unrubbed pastel. I must emphasize that the sparkle of unrubbed pastel is a unique property of the medium. I want to exploit this, and if I rub the work at all,

I do so discreetly to blend colours slightly, and then only as a contrast to textured pastel work.

I have shown examples of rubbed pastels in fig. 11 above. In the top left corner is a band of Lizard Green touching Cadmium Red and I blended the two together with my finger-tip. Alongside, I repeated the exercise, using bands of Lizard Green and Olive Green. I rubbed the right section to fill the paper grain. I repeated these colour bands below and hatched through them with Blue Grey to blend them together partly, resulting in a more vibrant effect than rubbing produces.

My mountain landscapes on the opposite page are similar in content, but fig. 12 is rubbed and fig. 13 is not.

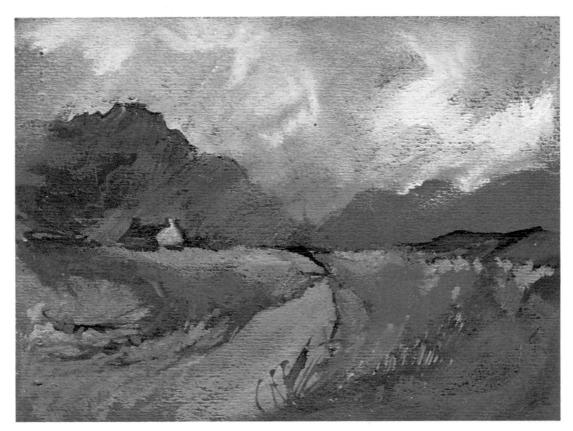

Fig. 12

Fig. 13

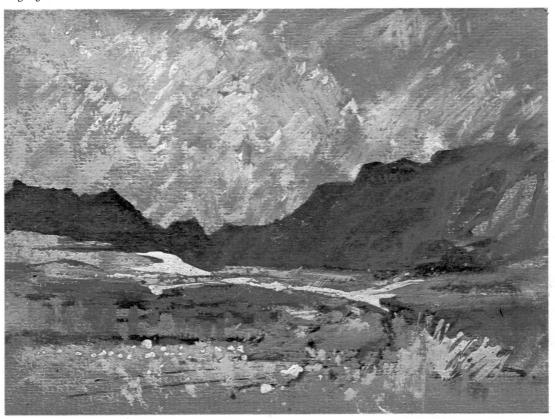

PAINTING FIGURES

People are fascinating to paint and almost everywhere we see wonderful characters. I love to make pastel studies of people, concentrating on capturing their attitudes, rather than facial likenesses. Tall, thin, drooping figures; short, almost spherical figures, they are all interesting to observe and paint with slight exaggerations, caricatured, but not too obviously. I like to watch people going about their normal activities. It is not always easy, or perhaps wise, to study obviously the people around you, but you can look long enough to record mentally the essential characteristics, possibly aided with a thumb-nail sketch.

The thought of painting figures can be frightening to the inexperienced painter, but some pictures do need a few figures. Imagine a street scene without them. If we remember that the figures for such a painting are usually just incidents within the whole content, and quite a small part of the painting, the fear begins to disappear. I am not saying that serious study of figures is unnecessary; I am talking in the context of fitting figures into a landscape or townscape.

It is often easier to deal with a group of figures. My small, rough sketch in fig. 14 was quickly done with the end of a brown pastel. I placed one light shape within a darker group, indicated the heads, and flicked downward strokes for the legs to produce a convincing enough group of figures suitable for a street scene.

I chose to do very little drawing for the lower figure – just enough pastel lines to indicate the man with his hands in his pockets. The drawing is not much more than an outline, and I didn't draw the feet, not because feet and hands are difficult to draw, but because I was not interested in them for the overall sense of this drawing. I gave some substance to the drawing by filling in the background with varied pastel strokes.

My painting on the opposite page suggests three figures out shopping. I tried to make the nearer figure more important by making her bigger than the others, contrasting her light, green-yellow coat against a darker coat, and inclining the heads of the other two figures towards her. I didn't indicate facial features because I was not interested in telling you that she had brown eyes – but I did want to indicate to you she is the dominant one and the others won't get a word in edgeways. Try to register the mood and activity of the figures, and the details will look after themselves. I didn't draw their legs very well, did I?

Try drawing a few simple figure groups and see how convincing you can make them with a minimum of drawing. Use a piece of charcoal or pastel so you won't have to worry about registering intricate detail.

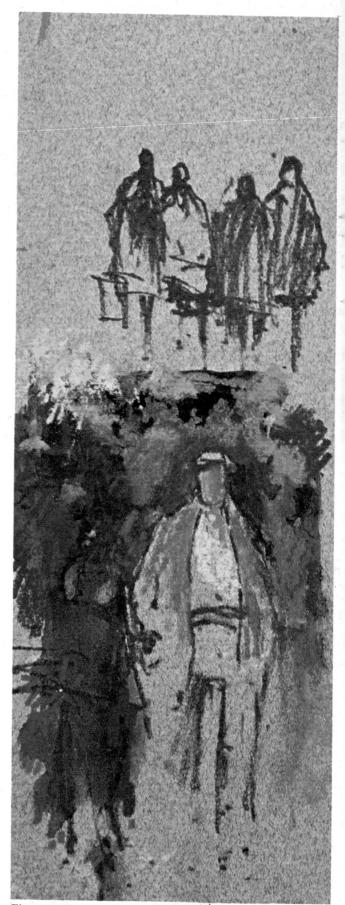

Fig. 14

MOORLAND COTTAGES

This painting summarizes the ground we have covered so far. The illustrations show the painting at an early stage and finished stage. I wanted a dramatic effect of dark stone cottages silhouetted against the light part of the sky and I chose a fairly dark paper, Fabriano Mid Grey. The cottages were placed high on the paper to make them important and leave plenty of space below for the elaborate textures of the foreground. I drew the outline of the cottages with a black pencil and immediately added some sky colour, Yellow Ochre Tint o. This light pastel leaves the grey paper for the cottages – a good example of effectively using the paper.

I left the sky unfinished and started to develop the fore-ground. I made pastel strokes of various colours, using short, quick strokes, and longer, lighter strokes and dots. It is impossible to describe every sequence and operation used for this involved foreground, but I developed it with these varied pastel marks. Some areas were painted with Sepia Tint 8, pressed into the paper to make very dark passages to show up the lighter parts. In some areas I twisted the end of a light pastel on to the paper surface to make abstract mottled light shapes, shown at the bottom left of the painting.

I was concerned about maintaining a dramatic sky, so I kept the colours of the foreground fairly muted, but elaborately textured. I had to keep from making too many strong contrasts of light and dark in the foreground because they would have conflicted with the sky. For this reason I avoided the vibrant effects of cross-hatching, but you will notice examples of that technique elsewhere in the book.

The light Yellow Ochre in the sky was applied with enough pressure to fill the paper grain – I wanted an intense area of light so I covered the paper. The light sky is further emphasized by the dark indigo used for the upper sky. I have explained that the Yellow Ochre was applied with pressure to form a flat opaque layer of pastel, and I contrasted this with short, broken cloud drifts of light and medium grey. Employing a different technique in a neighbouring area is a useful ploy to draw attention to part of a painting. This painting, with its textured foreground and dramatic sky, was not an easy subject, but does show interesting applications of pastel.

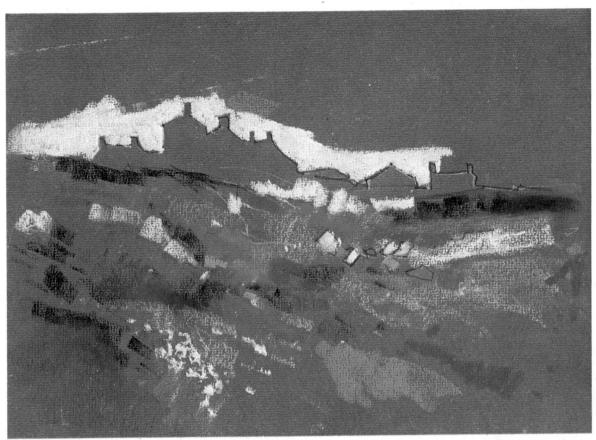

Early stage

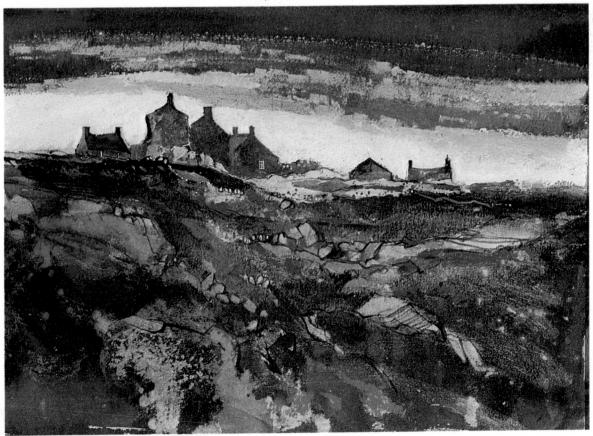

Finished stage

COTTAGE DETAILS

I saw this cottage in South Wales and liked the details of the windows. Then I walked to the back and was interested by this door which opened into the cottage. I made some pencil sketches and painted from them at home. The two men are imagined, although I am quite sure I have seen them somewhere.

The upstairs dormer windows sit comfortably into the slope of the roof and the whitewashed walls on each side of the windows make a good pattern of light, vertical strips against the bulk of the roof. Notice that some of the window panes are dark and some light. The downstairs window is set back in the thick wall, but windows are often incorrectly painted flush with the front of the wall. I took care to show how the upper part of the sash window overlaps the bottom half so that it can slide over it.

The walls of the cottage were whitewashed, but had weathered to reveal underneath layers of previous colours; pink and ochre. I obtained this effect by cross-hatching these colours over each other.

I treated the tree with caution and gave only hints of detail in the branches at the top. An elaborate tree would have competed with the window detail, so I painted enough detail to make the tree look convincing and no more. For the same reason, I understated the gate and wall details.

The door is a very simple subject which I painted to fit this page, but I may extend it sideways to include a window. This sets a little exercise for you to think about – should I extend it, or leave it alone? Is it complete in itself?

The building had been left unpainted. I liked the colours of the stone, warm grey with hints of red and blue, stained from rain and covered with green moss. The textured stone contrasts well with the plain door. The texture was obtained by dragging the side of the pastel over the paper, and by pressing dots of colour into the paper with the end of the pastel. The door is rubbed pastel: lightly applied red, grey and green, smoothly blended with my finger to contrast with the surrounding texture.

The shadow at the top of the door is important. I painted it with sepia, not black, with firm pressure on the paper. Sepia, or any dark brown tint, will give a good, warm dark, more subtle than black.

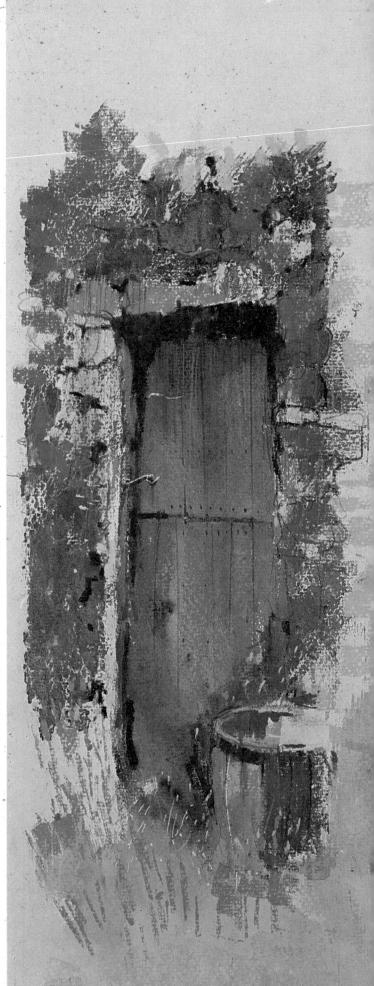

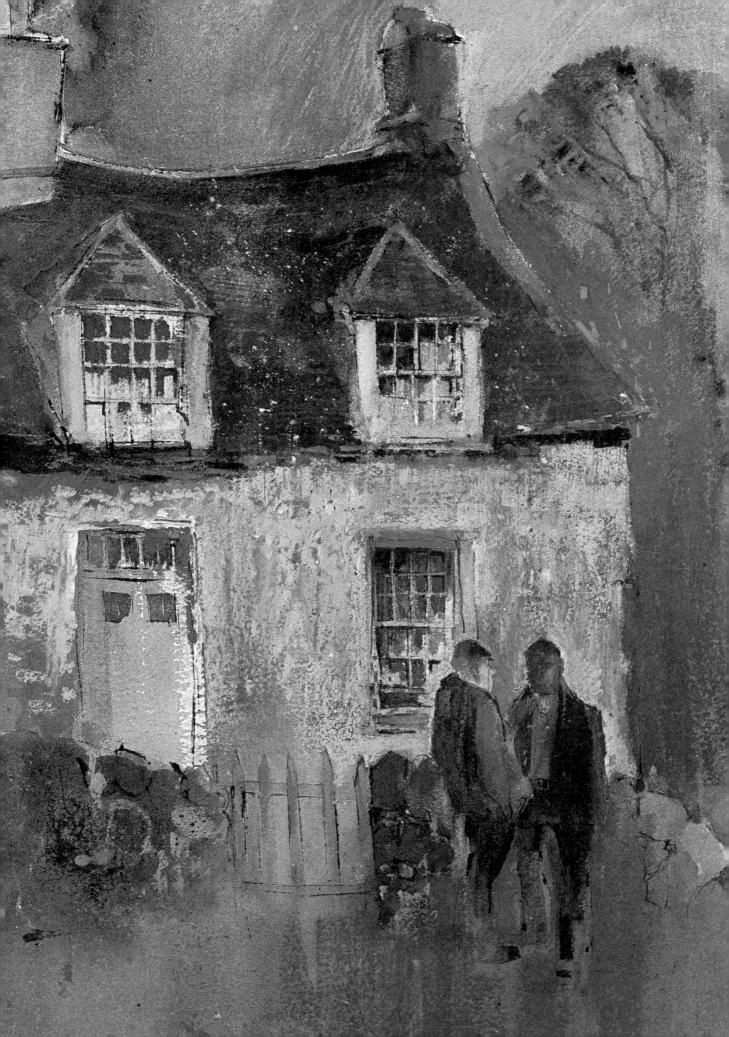

COTTAGE INTERIOR

I opened the door and walked into the cottage and made a pencil sketch on which I based this painting. I used Tan Fabriano Ingres paper and made use of it, letting it show

through in many places.

I enjoyed making this painting, with its mysterious darks and flickering highlights. It depended on these highlights, rather than the actual bits and pieces. In fact, with this sort of subject, we paint only what we see – glimpses of paint tins, highlights on bottles and glints of light on objects that we can't distinguish in the gloomy interior. It would be impossible to try to analyse accurately all the objects. Pastel is an excellent medium for this sort of impression – the opaque pigment makes perfect accents of colour on dark paper.

For the deep shadows, I used the darkest tints of Vandyke Brown, Purple Grey and Purple Brown, applying them in slabs of colour with sideways strokes. I shaped some with hard edges to form cast shadows; others I blended together to form soft, mysterious depths. I used lighter tints of these colours for the paler shadows and mid-tones. For the brilliant lights on the bottles and tins, I used touches of

Poppy Red, Sap Green and Blue Green.

Having hinted at the scattered objects, I concentrated some definition in a few places: the window, the large buckets, the corner of the shelves and the bench. I also added a little definition to some of the smaller objects on the shelves and introduced my own oil lamp into the painting. It gave a hint of definition within the impres-

sionistic treatment; besides, I like the lamp.

Up to that point, the painting had been made with sideways strokes of the pastel. I then added the light part of the wall by drawing strokes with light tints of Cool Grey, Blue Grey and Naples Yellow. These strokes were made with the end of the pastel, cross-hatching the colours over each other. I lightly flicked downward lines of Cool Grey over most of the painting, so the edges of the many features were broken and blurred, and the colour of one feature was dragged into another. These blurred edges help give a feeling of half-light inside the building, where objects are not clearly seen.

The important thing to learn from this painting is that definition can be limited to a few objects; elsewhere I relied on flicks of colour to suggest detail. Most of the edges are soft, but here and there a few crisp edges emerge and then melt away. A large part of the painting is concerned with suggested detail.

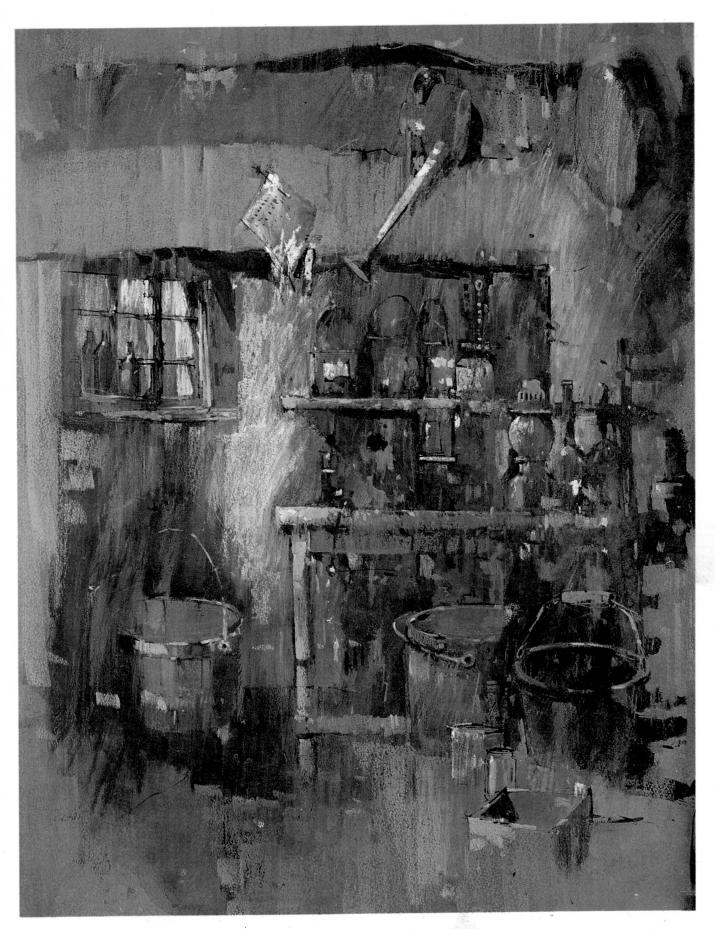

ANGLESEY COTTAGES

These cottages, with their chunky shapes, were ideal painting subjects, and the whitewashed walls gave excellent tonal contrasts. I enjoyed applying the pastel in a direct manner, unrubbed, to obtain the simplicity of the cottages. The full-size details of my painting show how the white pastel was applied in direct strokes, allowing the paper to break through to suggest the texture of the stone. Notice how the chimney at the far left looks like a solid cube of white stone, without ornamentation. I painted the white side with one broadside stroke. The paper, Fabriano Tan, shows through in the steps and parts of the foreground.

I outlined the cottages, steps and stones at the side of the steps with charcoal. The drawing expressed the positive shapes in the subject, while the rest of the painting is almost abstract, especially in the irregular shapes of the foreground. I didn't explain these because I wanted to concentrate on the steps leading up to the white cottages. I wanted the

viewer to walk up those steps, so I emphasized the stones on the left. I also tried to attract the viewer by pressing the pastel hard into the paper to intensify the white on the right end of the left cottage.

Every time I make a pastel stroke, I query its purpose and ask myself if I want to draw attention to it. The stones to the left of the steps are hard-edged and contrast in tone, and I outlined them. By comparison, the stones to the right are subdued, so they don't compete with the left and cause the eye to jump from one side to the other. This sort of thinking becomes instinctive with practice, but you have to work at it by always asking yourself questions.

You can see from this discussion that painting is concerned with not only methods and technique, but also ways of seeing and thinking. Try to choose some aspect of the subject that interests you, and discipline yourself to concentrate on that one message.

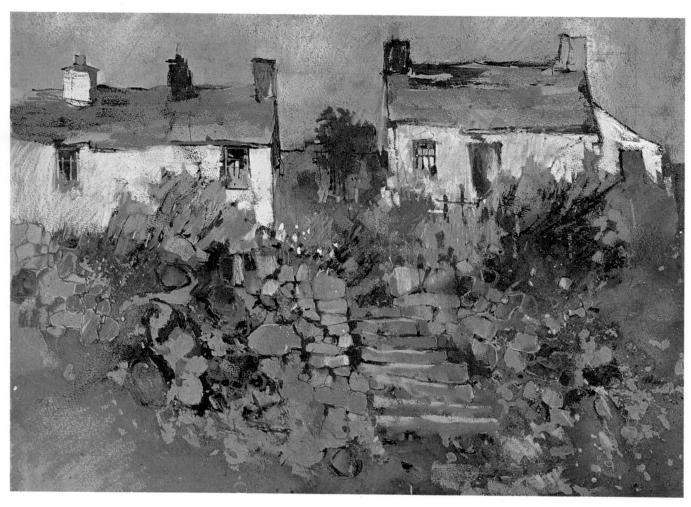

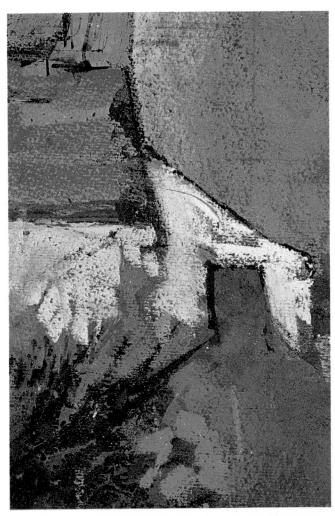

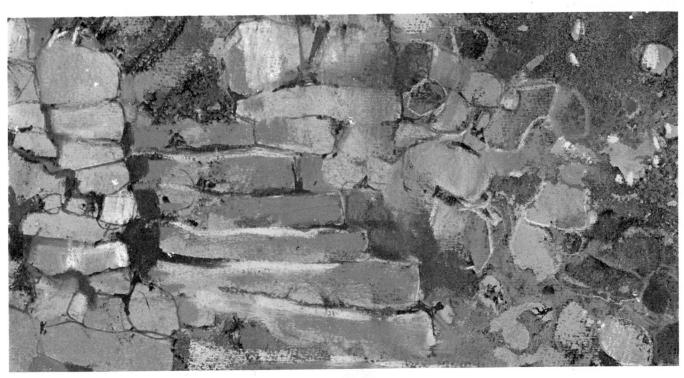

First stage

Second stage

STAITHES, YORKSHIRE

We have been talking about working on paper specially made for pastel painting, but I now want to introduce the possibility of tinting paper ourselves. Good quality cartridge or watercolour papers are readily available and can be tinted with watercolours. We can tint the paper one colour all over, or in various colours. For example, the paper could be tinted grey at the top – as an underpainting for a pastel sky, and the lower part could be painted Raw Umber for the ground. Here, I extended this process by painting a misty sort of watercolour to use as a basis for a pastel painting.

First stage I pencilled the outline of the building on a not too rough piece of watercolour paper, very lightly so that it was only just visible. Then I mixed some Raw Sienna watercolour with water in a saucer and brushed it all over the paper. While this was still wet, I brushed a mixture of Cobalt Blue watercolour on the top left corner, and a weaker mix of this on the bottom half of the paper. While the paper was still wet, I added some brush strokes of Burnt Umber, Raw Sienna and Light Red watercolour in the middle. These brush strokes can be seen in the finished painting as soft-edged, shadow-like drifts of colour.

Second stage I mixed Burnt Umber and Cobalt Blue watercolour together, with a little water, and brushed this mixture into the damp paper to form the shape of the houses, leaving the blue sky of the first wash uncovered. This is where the pencil outline was useful. The process of painting a shape such as this into a damp wash requires a good deal of practice, so don't worry if your first efforts are not as successful as you would wish. It is not necessary to produce a perfect watercolour painting – you only need to produce a change of colour, grey-brown for the general area of the buildings, and blue for the sky as a base on which you can pastel.

Finished stage I started to pastel over this misty water-colour impression by slightly emphasizing the distant chimneys with various tints of Warm Grey. I also dragged some of this colour over the general area of the buildings to create some stone texture. I defined the nearer buildings with Purple Grey Tints 4 and 6. While doing this, I left a lot of my watercolour painting still showing and mostly concentrated the pastel on the chimneys. This was enough to clarify the nearer buildings, leaving the distant ones less definitive. Then, with great enjoyment, I registered the bright roofs with Raw Umber Tint 1 and touches of

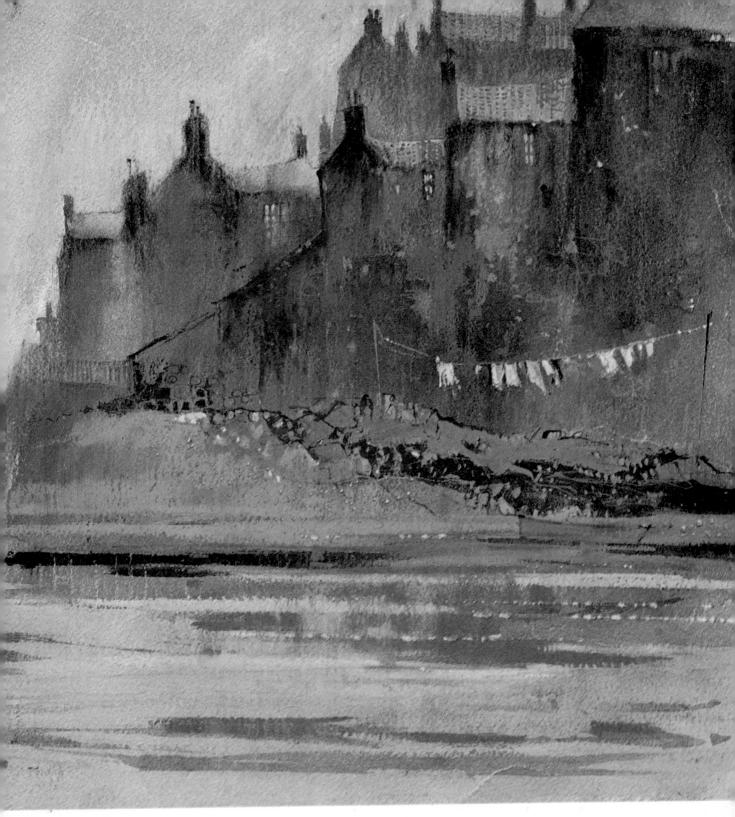

Finished stage

Madder Brown Tint 2. I continued to liven up the painting by very lightly dragging Hooker's Green Tint 1 over the sky and water. I used tints of Raw Umber for the beach, with Sepia Tint 8 for the dark parts. The water was completed with horizontal strokes of Green Grey Tint 4 and Cobalt Blue Tint 0. Finally, I indicated the boat, added a few varied tints within the buildings, dotted a few highlights, and hung the washing on the line!

LOW WATER

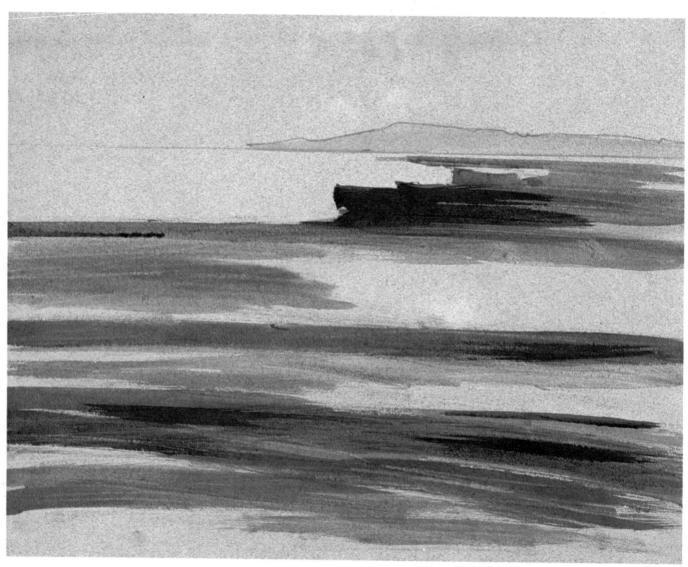

First stage

This subject had strong contrasts of dark and light passages, so I immediately realized that it would be helpful to use a light paper with some dark colour washes added to it. This gave me the best of two worlds: a piece of paper which was both light and dark on which to pastel. Instead of tinting watercolour paper as I did in *Staithes*, I chose a tinted pastel paper, Tumba Purple Grey. The colour of this paper matched the colour I had in mind for the sky and the water.

First stage With a stiff oil painter's brush I made dark sweeps of Cryla acrylic paint across the bottom of the paper and in the area of the boats. I used Burnt Umber, Coeruleum, Olive Green and Burnt Sienna Cryla colours. This process requires little or no skill; the brush strokes are applied quickly and crudely, only to register the general pattern of light and dark. The advantages of Cryla colours are that they dry very quickly and give a good surface on which to work. Designers Gouache colours also give an admirable base for pastel work. The general pattern of the painting was then established and even this crude image

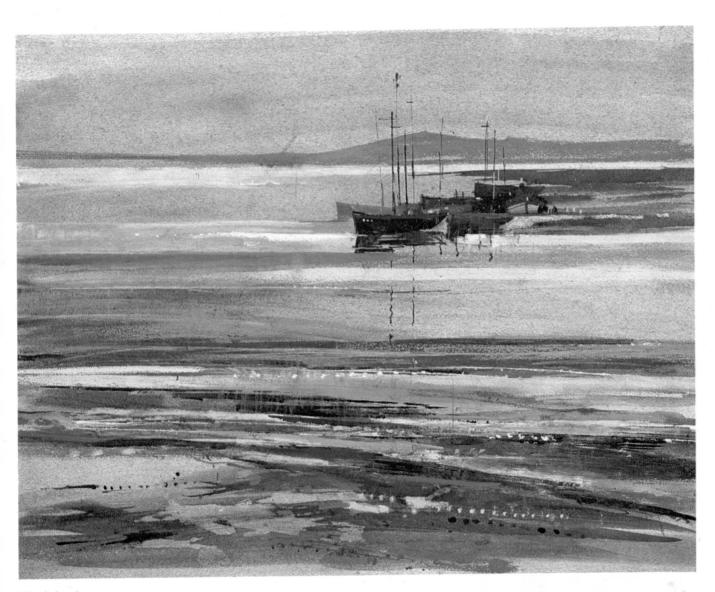

Finished stage

suggested the light passages of water and the dark boats.

Finished stage I then started to apply pastel. I defined the boats quickly by applying light pastel to the surrounding water, leaving hard-edged shapes of the dark underpainting to represent the group of boats. I would like to emphasize that I didn't paint the boats themselves, I explained them by painting the surrounding water. Later, I added a few touches of Burnt Sienna pastel to suggest the paintwork of individual boats. I continued to explain the water by drawing strokes of pastel across the paper, using

Blue Grey Tints o and 2, Coeruleum Tint o, and a little White. I left bands of the paper showing. These strokes of pastel were applied decisively from left to right, with a good deal of pressure. I continued this treatment in the foreground to make the dark passages of mud and streaks of reflected light. I used tints of Vandyke Brown ranging from Tint I, which is almost pink, to the very dark Tint 8. Finally, with the end of the pastel, I made light dots to create sparkle. This has been my aim – to emphasize the intense contrasts of the dark boats and mud against the bright water.

First stage

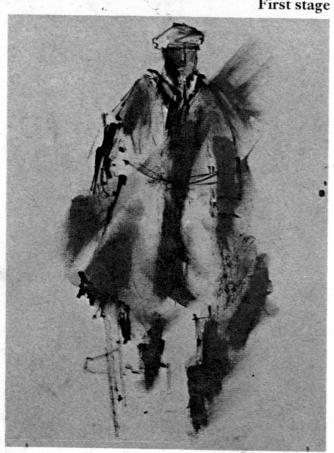

Second stage

HILL FARMER

This painting was based partly on imagination and partly on memory. I paint a great deal in mountain and hill country, so I frequently meet farmers looking for sheep on the mountainside, in the wind and pouring rain. I wanted to capture these conditions in my painting.

First stage I drew the figure on Blue Grey Tumba Ingres paper with a blunted wood cocktail stick dipped in black drawing ink. When the stick was first dipped into the ink, it produced a dense black line, but the stick quickly absorbed the ink so the line became grey and broken, giving an interesting change of density.

Second stage While the ink was still wet, I smudged parts of it with my finger-tip to create patches of black. The idea was to have, instead of blue-grey paper all over, paper that was grey in some parts and black in others. You will see the purpose of this in the next stage. When the ink was dry, I started to block in the pastel background with strokes of Grey Green, Indigo and Burnt Umber and added touches of these colours and Raw Sienna to the coat.

Finished stage Then I really started to make use of the ink drawing. I dragged a light pastel, Madder Brown Tint 2, over the dark ink in the face, and a dark pastel, Burnt Umber Tint 8, over the light side of the face. The purpose of this seemingly contradictory process was to intensify the brightness of the light pastel by allowing the black ink to show through. The hands, and other bright accents in the painting, are also emphasized by dragging light pastel over black ink. I was careful to apply the pastel in gentle strokes so the black ink was not obliterated.

As a contrast to the bright highlights, I wanted some dark, hard-edged shapes, so I painted the cap, trousers, boots and parts of the coat by pressing the pastel firmly into the paper. It is important to have solid, blocked-in shapes such as these as a foil to the free pastel strokes elsewhere. As I painted the boot, I carefully shaped the heel, because I think that small, accurate statements such as this give a feeling of conviction within the overall impressionistic style of the painting.

Then came the rain, slicing across the painting. This could not be treated tentatively. I subdued any fear of spoiling the painting and attacked it, slicing lines of pale grey across it. This vigorous drawing action cut across the edges of the figure, breaking up the edges so the form of the figure was partly lost in the rain.

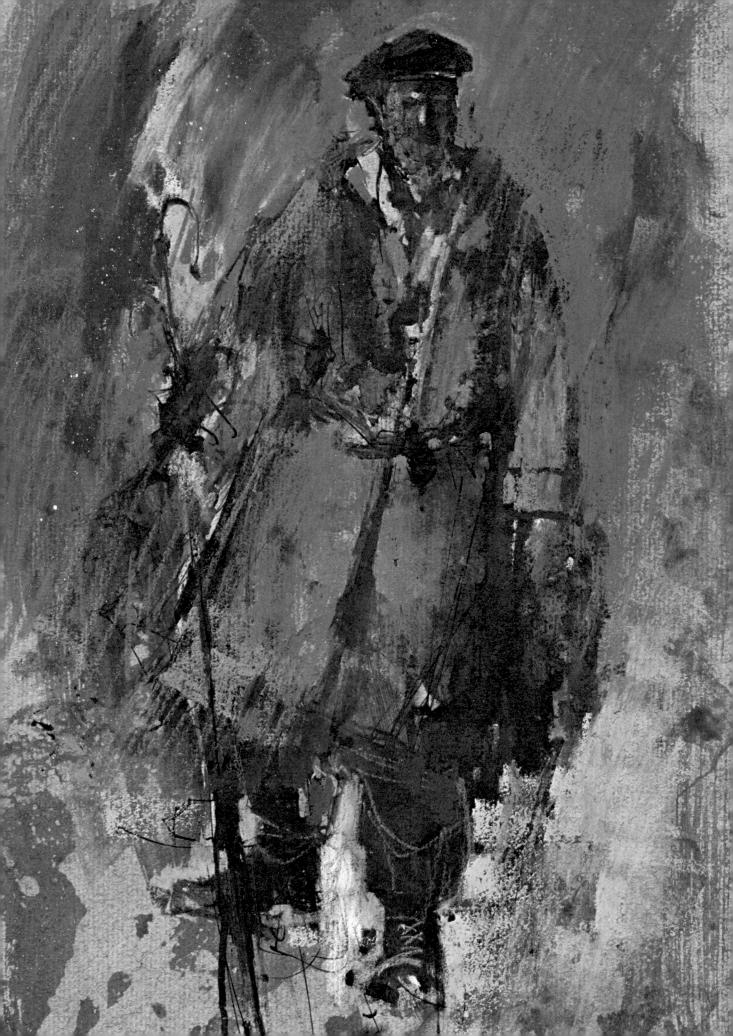

PORTRAIT

Portraits are often painted with almost photographic accuracy and pastels are very suitable for this sort of finish. The pastel can be rubbed into the paper to give a smooth surface, and to blend and fuse the colours to give subtle gradations in the flesh tones. This sort of treatment was very much favoured in Victorian times and some painters continue this polished treatment today, with remarkable results. I prefer a less finished surface; I like to see the way the pastel has been applied with open, unblended strokes. The skill here lies in accurate judgement of the colour and tone of neighbouring pastel strokes. If they are correctly chosen, they will sit comfortably alongside each other, but still show the spontaneity of the medium.

The first thing was to decide which tone and colour of paper to use. This is particularly important with portrait painting where the tonal variations of the flesh can be very subtle. There is a danger with a dark or a very light paper that tones can contrast too much. I chose a mid-tone grey, Fabriano Stone Grey Ingres, to help me achieve the tones of the face. I used this mid-tone as a starting point and worked either side of it with slightly paler or slightly darker pastels, gradually building up to the main highlights and the darkest parts. When I painted the darker parts, I dragged the pastel gently over the paper, allowing the cool grey to break through the pastel and suggest cool tints within the dark areas. This process was especially useful in the shadowed parts.

Diagram and first stage My first step was to draw some guiding lines. I did these decisively and crisply. While making the drawing, I related points and lines to each other. I noticed the triangle formed by the points at the base of the nose and the ends of the eyes. I looked for the top of the ear and related it to the level of the eyes. I noticed that the outer slope of the ear was parallel to the slope of the nose, and the slope of the nostril echoed the slope of the eyebrow. I made a separate diagram to show you these relationships. I do not consciously strive for a likeness of the sitter. The likeness will come if I accurately judge the relative spacing, positioning and angularity of these points. Sometimes, I slightly emphasize the angularity of a line to bring out a particular characteristic that interests me.

In drawing the portrait, I used combinations of Blue Grey Tint 4 and Warm Grey Tint 3. I then added tentative slabs of tone, in Green Grey Tint 1 and Blue Grey Tint 4, with sideways strokes of the pastel, just to start feeling my way into the process of painting.

Second stage I first looked for the main structural planes of the face and indicated these lightly, but decisively, with sideways strokes of Green Grey Tint 4. Detail was ignored and I looked for the shape of the eye socket and massed it in with flat slabs of colour. Notice how the eye socket is mostly in shade. This is because the underside of the eyebrow was turned away from the light and cast a shadow which extended below the eye. Within this shadow, a little area of light caught the upper eyelid where it curved over the eyeball. The upper lid also cast a line of shadow on the top of the eyeball, whereas the lower lid melted into the face. Many beginners make the mistake of drawing a line around the whole eye – the only line is under the upper eyelid. I extended the tone of the eyebrow as a continuous shape down the side of the nose, over the cheek and under the nose.

The colours I had used so far were mostly Green Grey and Blue Grey. I then indicated some flesh tints with Burnt Sienna Tints o and 2 on the forehead, nose and chin. I also added a little background tone with the Blue Grey to help me define the shape of the face. I indicated the cap and jersey with slabs of Indigo Tints 4 and 6.

Third stage This was a fairly simple stage, where I began to strengthen the colours and tones already on the paper. I added more Blue Grey to the shaded eye socket and the side of the nose, and a little Green Grey under the nose. While doing this I was careful not to cover up and overwork the previously applied pastel; leaving some of this pastel uncovered gave a look of freshness. I dragged a little Indian Red Tint 2 over the cheeks, forehead, nose and chin, and began to place the highlights with Burnt Sienna Tint o. The eyes were slightly darkened with Warm Grey pastel.

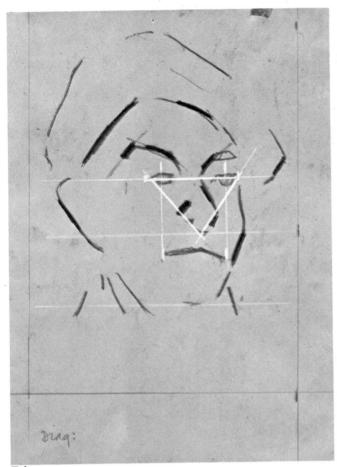

Diagram

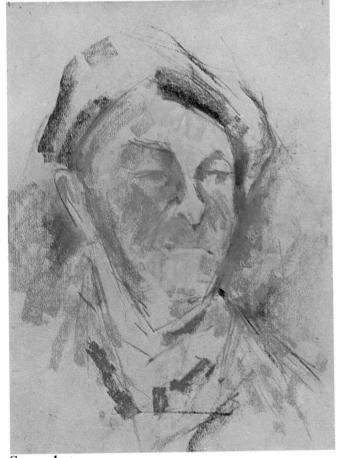

Second stage

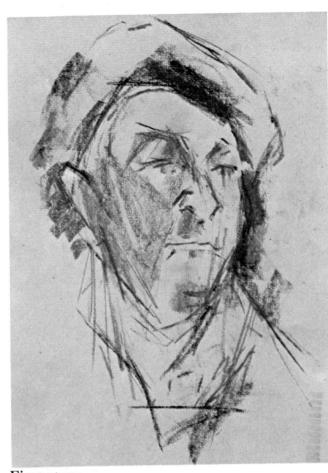

First stage

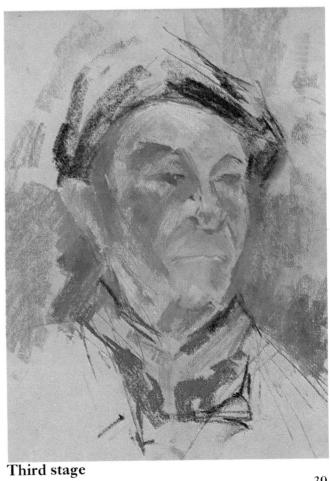

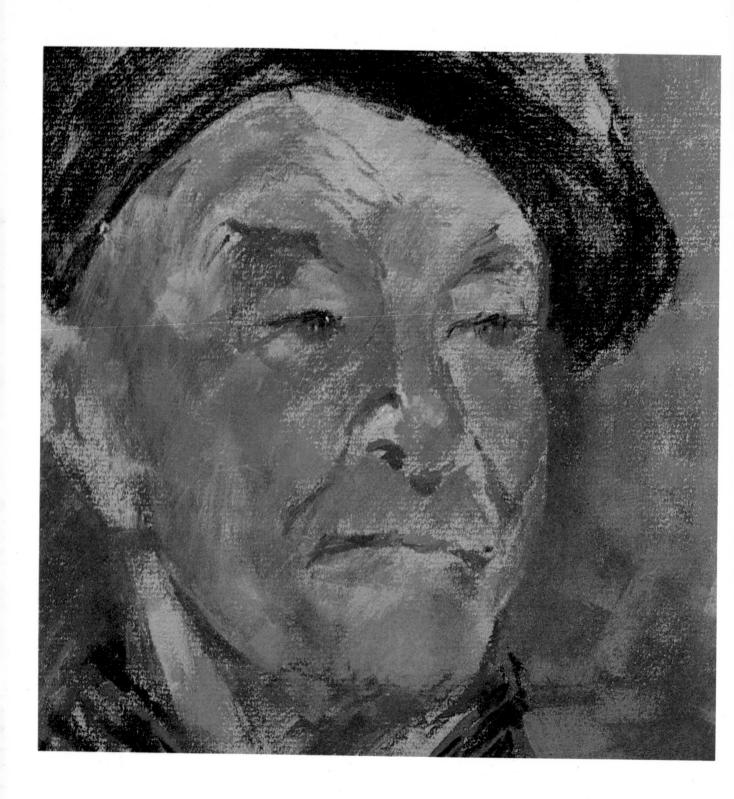

Finished stage I quickly massed in the background, repeating some of the colours I had used in the face: Warm Grey, Green Grey and traces of Burnt Sienna. The cap was strengthened with Indigo firmly pressed on the paper. I continued to build up colour on the face – repeating the previous colours with greater pressure, always leaving some of the previous applications uncovered. Notice that I didn't paint the white of the eye; I left the original grey,

adding just a little more pressure to the dark shadow of the eyelid, to give just the merest hint of highlight. If you ever wish to paint the white of the eye, never use white – use a pale grey such as Cool Grey Tint 1. Also notice that I used hardly any colour for the mouth – I just indicated the upper lid and used a hint of light pastel for the lower lip. The jersey was blocked in with bold strokes of Indigo and touches of Black.

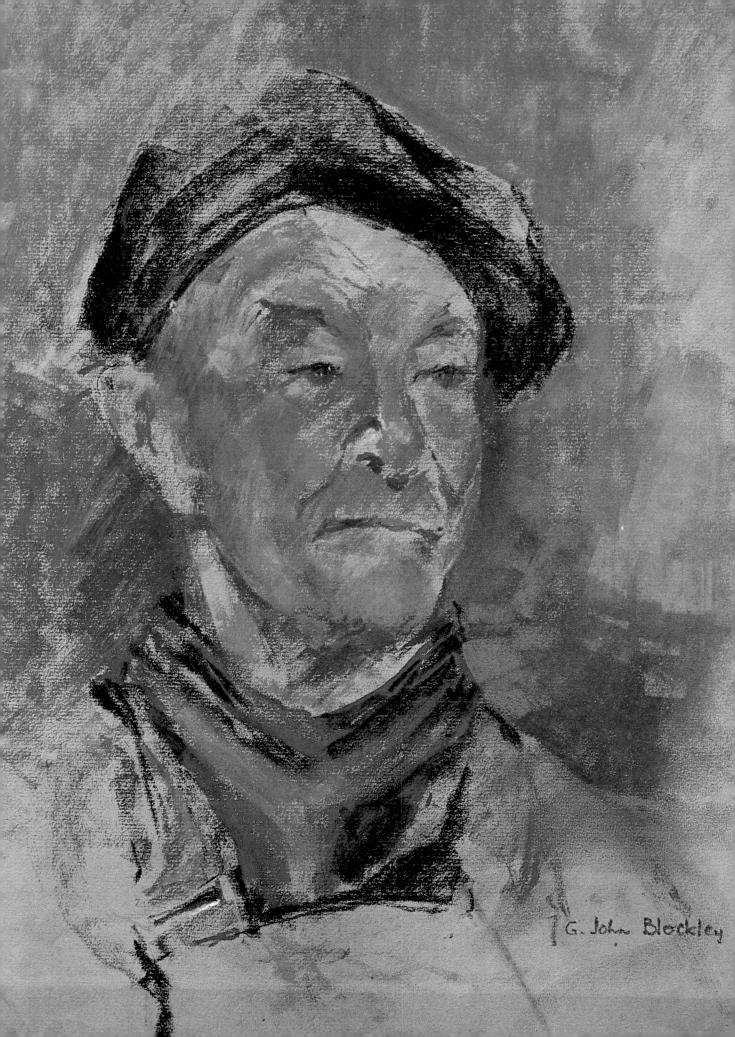

A NORTHUMBERLAND HOUSE

This very old house attracted me with its weathered, tiled roof which is now partly covered with lichen and moss, with some of the original orange colour of the tiles showing through. Before we start painting it will be useful to think about the perspective of the main building with its two projecting wings. The mention of perspective usually causes an anxious frown but it is really not all that difficult. It will be easier if we think of the building in two parts. First, we think about the fundamental perspective of the left wing of the building. We are looking towards its end in the direction of the arrow, and from this viewpoint the roof and all the lines in the building taper away from us. This is especially noticeable in the roof, which slopes downwards and away from us. If we remain standing in the same position we see the end of the other wing in the direction of the arrow, and its roof and building lines also taper away from us. If we put the two diagrams together, we arrive at the complete building.

First stage I used this perspective diagram in drawing the building. You will almost certainly wish to draw a building such as this with a pencil first to make sure your drawing is correct and the building fits on the paper. Sketch the whole building very lightly so you can more easily make adjustments. It is very irritating to find that you have been drawing the parts too big and there isn't enough room on the paper to complete the whole drawing.

I prefer to start drawing straight away with an ordinary pen nib. For this painting, I used brown drawing ink and

Stone Grey Fabriano Ingres paper. I drew the outlines with positive pen movements, slicing the pen across the paper. Sometimes, the pen draws a single line and occasionally I quickly dash in another line or two, close together. This is done deliberately to avoid a 'tight', over-careful appearance in the drawing. I also admit there is some bravado in it - to break down the initial fear of the empty paper. I always feel a tingle of apprehension or expectancy when faced with a clean piece of paper. Another reason for drawing a multiple line is that it might set up some rapport with the viewer if it shows up in the finished painting. I hope to give him a feeling of involvement with the painting by letting him discover and question the initial exploratory drawing. I have discussed the drawing part at some length because I want to point out that even the simple action of drawing a line has an emotional and personal side to it.

Having drawn the main outlines of the building, I used a paint brush and brown drawing ink to block in the dark areas. This did two things: it quickly gave a feeling of volume and bulk to the outline drawing and gave me areas of dark brown, in addition to the grey of the paper, on which to pastel. Notice that I now have a pattern of tones: dark on the end of the building, then a light area, then another dark section, and so on. This is known as 'counterchange'. I also want you to notice that I did not fully draw the windows, because I wanted to concentrate on the shape and volume of the building and the arrangement of dark and light areas. I did not draw a line along the base of the house because I wanted it to blend with the ground; not look as though it had been just placed there.

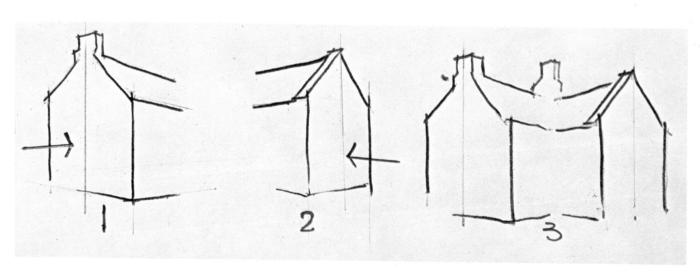

First stage

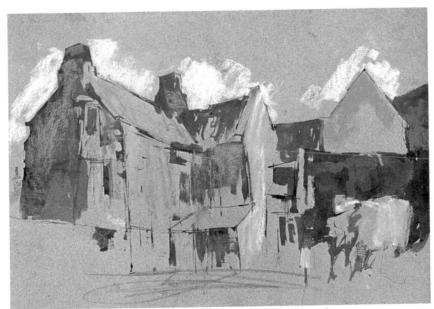

Second stage

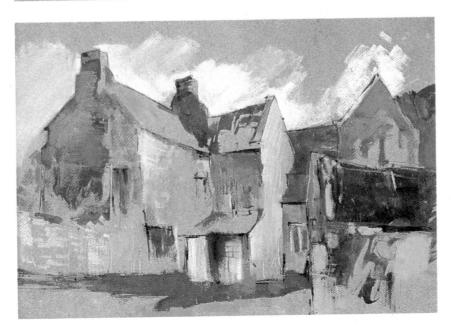

Third stage

Second stage I began to add pastel over the drawing. The important thing I had to remember was to apply the pastel lightly, not pressed too hard into the paper, because I was still at the exploratory stage of feeling out which colours I wanted to use. I also had to remember that the pastel should be spaced out over the whole of the paper and not concentrated in one place. I am more likely to achieve unity in a painting if I keep the painting progressing as a whole, rather than finishing one small part at a time.

I used the pastel on its side to make short bands of colour on the painting. I placed a few strokes of Silver White around the chimneys and a little Purple Grey Tint 1 in the sky. I tried a few strokes of this Purple Grey on the light side of the buildings, a few strokes of Blue Grey Tint 2 on the dark side and a very tentative stroke of Cadmium Orange Tint 6 on the roof. I immediately recognized that this was too bright and colourful, and made a mental note to subdue it with Raw Sienna at a later stage. This shows the advantage of making the first strokes light and exploratory, because I can now adjust the too-bright orange by dragging Raw Sienna over it, without having to erase.

Third stage This was a relatively easy operation of adding pastel to what I had done in the previous stage. I strengthened the colour by pressing pastel strokes over the first layer. In some places, I merely added colour over the same colour, and in others I modified the first colour by overlaying it with another. For example, I felt the white of the sky should be subdued, so I overlaid it with strokes of Purple Grey Tint I and Coeruleum Tint 0, so that hints of pink and pale blue-green began to appear in the sky. I extended the grey pastel over the inked parts of the building and added a little indication of the tiles to the small fore-ground building.

You will remember that when I painted Hill Farmer I dragged light pastel over ink so the dark ink showed through and emphasized the light pastel overlay. In A Northumberland House, the purpose of the ink was to darken the ends of the building; thus quickly explaining the volume of the building. I was not using the ink to emphasize the lighter, overlaid colour as I did in Hill Farmer. The painting was then at an advanced stage, with the pattern of light and dark and the choice of colours established.

Finished stage I expanded the various colour patches to fill in the uncovered paper, but I was careful to leave some paper uncovered so that quite a lot of its grey colour plays a part in the painting. I increased the amount of grey pastel on the chimney top, and at the top of the pointed wall at the right, so these features were strongly silhouetted against the sky. I added a little definition here and there — to the window panes, the white door and the stones in the walls. The trees were quickly blocked in with tints of Green Grey, and I used the Blue Grey of the walls to cool down the strong foreground shadow.

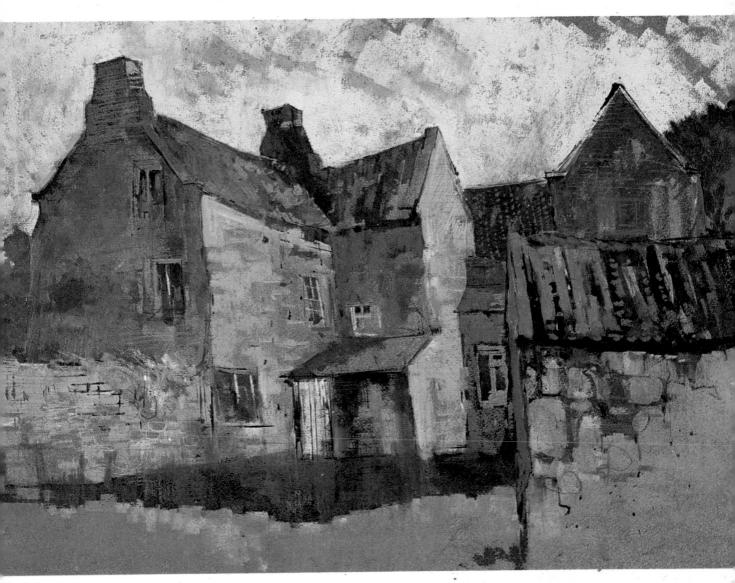

The painting is now finished. Let us have a look at it and pick out some important points.

I would like you to notice how I allowed the grey paper to break through the pastel throughout the painting. It breaks through the light sky, shows in the building and the ground, and harmonizes with the pink and blue-grey pastels that I used, giving the painting an overall unity. The choice of paper colour also saved me a lot of work because I was able to leave quite a lot of it uncovered. It will be a useful exercise for you to look at the painting and try to find the uncovered parts. They are not obvious at first glance, and I think you will find yourself looking quite hard and questioning whether some parts are paper or pastel. This indicates a successful use of the tinted paper.

The feeling of unity in the painting was also helped by using only a few pastel colours, mainly shades of grey and pink. The harmony would have been destroyed if I had scattered a lot of bright colour around the painting. I

allowed myself one accent of colour by placing a stroke of orange in the roof of the near building, and I gave a slight echo of this in the roof of the large building.

Notice how some line directions echo others. The chimneys have small, sloping parts that echo the larger slopes of the roof. These are positive echoes that actually occur in the building, but notice that I contrived some further echoes by making some pastel strokes follow the slope of the roof. This is especially evident in the grey paper left in the sky at the top right, where I applied the pastel in diagonal strokes, repeating the slope of the roof. Let us think about this a little further. When I painted the sky, I began by asking myself: 'How light is the sky?', 'What colour is the sky?' and 'How do I apply the colour – can I do it in an interesting way?' You should cultivate a habit of looking for interesting characteristics in a subject and finding ways of expressing them in pastel. Painting depends upon keen looking and good technique.

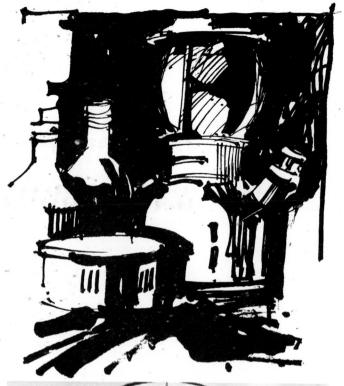

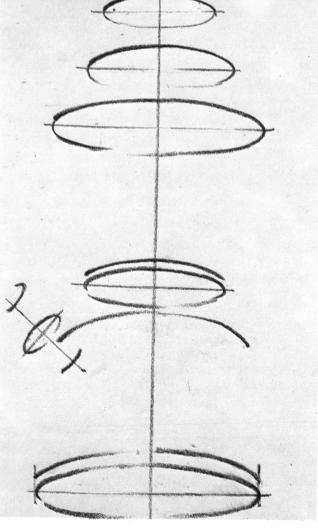

OIL LAMP

I am rarely interested in painting still life groups such as pots and glass jugs carefully arranged in front of a drape. I prefer to paint a group of objects just as they occur. After all, we can't rearrange the landscape and we paint that as it is, with perhaps a few adjustments. So with a still life group I never pose the objects; I wait until my eye is caught by a group of objects lying around just as they were left, preferably in some disorder. When considering such a group don't think that all the objects have to be wholly contained within the picture. There are many paintings by leading artists where objects are cut in half by the edge of the painting. It is much more important that the arrangement is interesting, as a pattern, or in colour relationships, than nice and tidy.

It is useful to make a few simple sketches to try out such compositions. My brass oil lamp normally hangs in a corner of my studio, but the very quick pencil sketch which I made some time ago shows it standing on a bench surrounded by other bits and pieces. I viewed the group from different angles and made a number of little sketches, fitting the objects within a roughly drawn frame. In this sketch I aimed for a satisfactory arrangement of dark and light shapes of varying sizes. I was primarily concerned not with fitting the oil lamp itself into a picture, but with the way its shape related to other items standing on the table.

I did not rearrange any of the items, and was not overconcerned with any one item. Indeed, I was not worried about having cut off the top of the lamp – I was interested in the group as a whole. I looked at the shape of the items and the spaces between them. Negative shapes, as these spaces are called, are often as interesting as the shapes of the objects. It is a good idea to make little sketch motifs with a soft pencil or piece of charcoal, concentrating on the shapes and light and dark tones. Walk round the group, look down on it, view it from below, and don't move anything. See if you can design a satisfactory composition within the existing group.

First stage For this painting I concentrated on the lamp itself, hanging, as it usually is, from a beam in the corner of my studio. The lamp demanded accurate drawing, especially as I decided to make it the only feature in the painting. My diagram shows how I started to construct the lamp by drawing a vertical line through the centre, and then horizontal lines on which I drew the ellipses of the lamp. When I drew this basic construction, I had to judge how far apart the ellipses were. This can be done by mentally comparing the relative distance between them, or measuring each distance with a pencil held vertically, at arm's length. I also had to compare the spacings of the ellipses

with their widths. My problem was not only to draw accurately the ellipses, but also to judge the width and depth of each one, and fit them all in their correct spacing relative to the height of the lamp, which in turn had to fit into the height of the paper.

This element of judgement is present in all drawing, we have to judge the width of a window in relation to its height, and the spacing between the windows. This judgement obviously comes from practice, so it is a good idea to make such mental measurements whenever you can, not just when painting, but even when you are walking down the street. Stop, and mentally proportion the windows and doors, and if you have time to stop and draw the proportions, so much the better. It is not easy to fit all the sizes and proportions into a given paper size, so it is good to carry out such exercises whenever you can.

Once I completed the basic drawing construction, I was ready to start the painting. I chose Tan Fabriano Ingres paper, because it roughly corresponded to the dull brass of the lamp and I was able to let some of the paper show in the painting. I drew the outline of the lamp with charcoal. For the purpose of this demonstration, I drew a

much stronger line than I normally do, but charcoal is easily removed by flicking it with a cloth, and I did this before applying the pastel.

Second stage I studied the tones and colours of the lamp. Within the brass parts, there were subtle changes of colour and only a few really dark tones. I decided to leave these subtleties for a while, and get on with the easily-identified dark passages. The light came from the left, so the lamp cast a shadow on the timber frame from which it was hanging. This was a positive area with which to start. I used a piece of Madder Brown Tint 8 pastel about 1 inch long and drew a band of colour down the paper, following the contour of the lamp. This one downward stroke of pastel defined the profile of the lamp and cast shadow in one drawing action. The bottom part of the lamp cast a big, rounded shadow, and I used Indigo Tint 4 to extend the Madder Brown shadow to make this interesting shape.

I worked a little Indigo into the shadow near the glass bowl. This change from brown to indigo introduced a little variety into the shadow. The brown and indigo are similar in tone, that is, they are equally dark, so they blend together

First stage

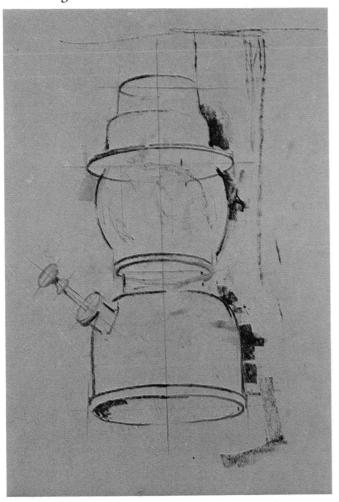

Second stage

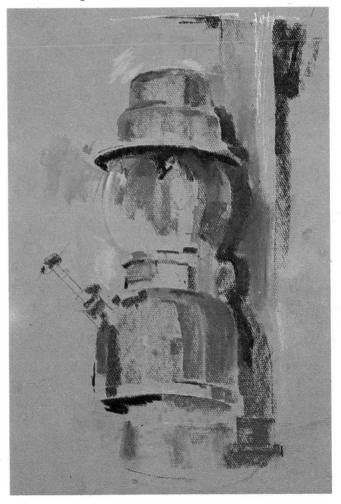

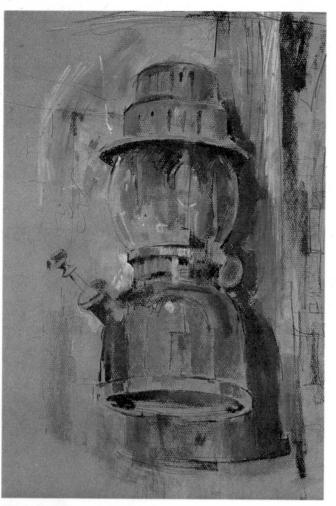

Third stage

nicely. With the same tint of Madder Brown, I registered the other darks; under the top rim of the lamp, on the base of the lamp and in the shadow behind the timber frame. These dark passages, on the tan paper, immediately gave volume to my outline drawing and the painting took a rapid step forward.

My painting then consisted of the light charcoal outline and the dark shadows, and I began to consider the lamp itself. I drew bands of Hooker's Green Tints 8 and 5 and a little Warm Grey Tint 3 for the glass bowl. I used bands of Warm Grey Tint 4 and a little of the Hooker's Green for the brass parts. I left quite a lot of the paper uncovered. There is always a great temptation to put in the highlights at this stage, but I like to leave these until the end.

Third stage The painting needed some finishing touches to pull it together, so I strengthened the dark shadow at the bottom and the dark parts of the lamp. I intensified the lighter parts of the lamp by adding more of the original colours with increased pressure on the pastel.

Finished stage I merely repeated the colours to cover more of the paper surrounding the lamp. I added a few accents of green and grey on the lamp, and hinted at the white mantle inside the glass. Finally, I firmly placed the few highlights.

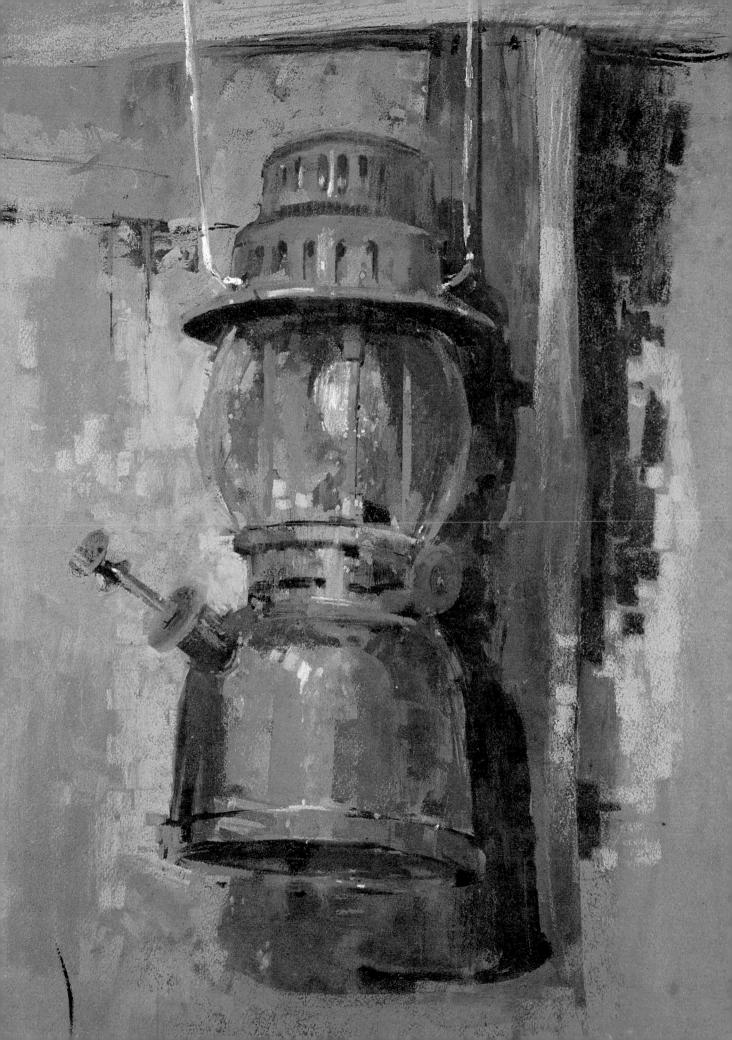

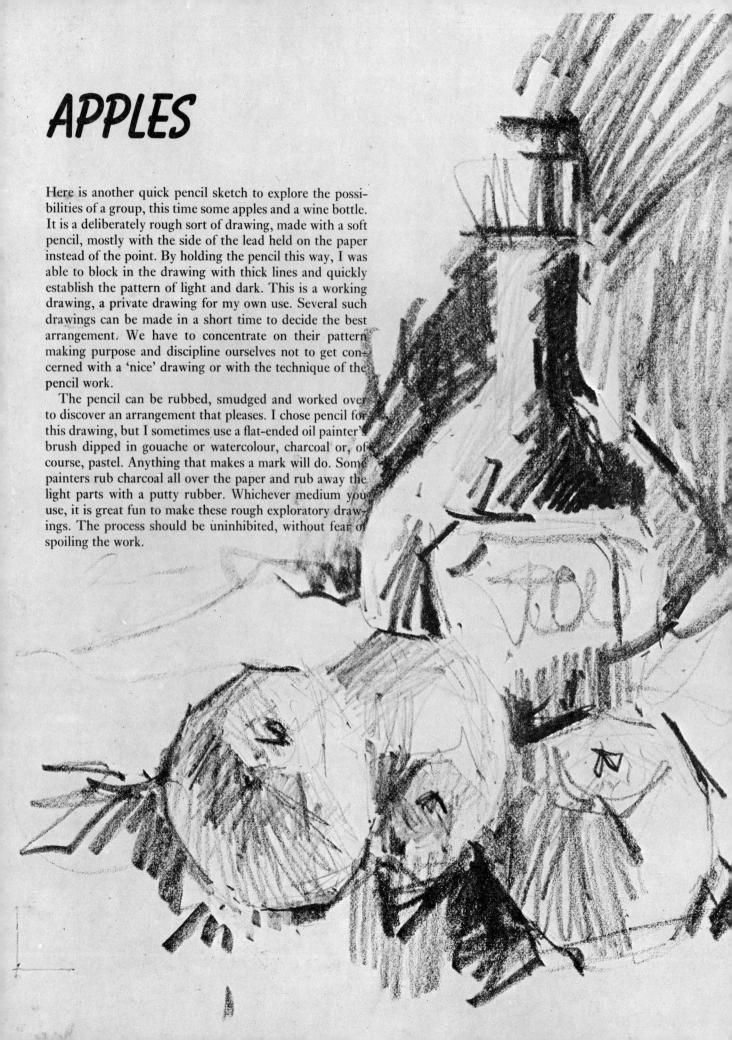

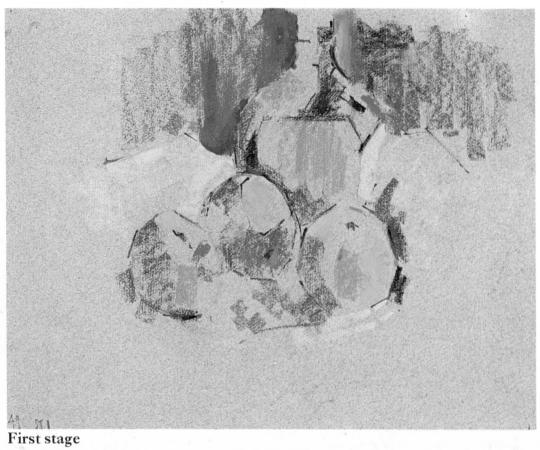

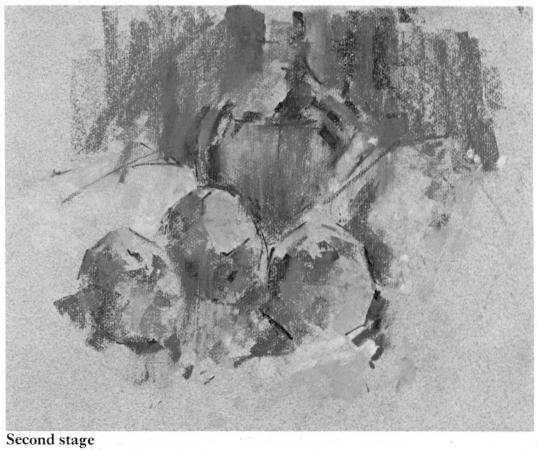

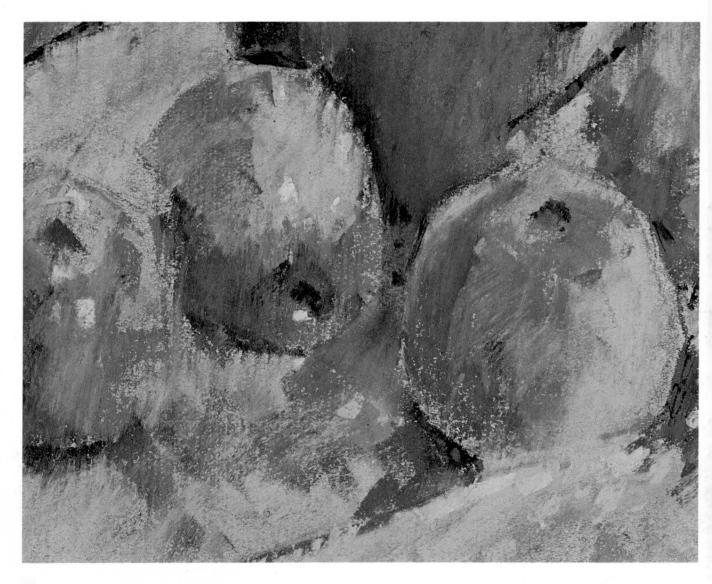

In the later stages of the painting, you will see that I applied the pastel with the same positive strokes but I used the side of the pastel lightly, so I did not fill the grain of the paper. I wanted the paper to break through to give a luminosity to the pastelled surface. I thought of the curved surface of the apples as being built up with a number of almost flat planes – like the facets of a cut diamond – so I made short, rectangular slabs of colour. The directions of the pastel strokes are important – they follow the general curve of the apple, but with short, angular changes of direction. This treatment is one in which the quality of the pastel application is of great importance. I wanted to involve the viewer and invite him to examine the way the paint was applied.

I had a growing feeling that I wanted to keep the painting light and sparkling with some space around the group of apples. I think this feeling came from the light reflecting from the apples. They are fresh, green and bright, with small flashes of highlights on their smooth surfaces, which echo the glints of light in the folds of the

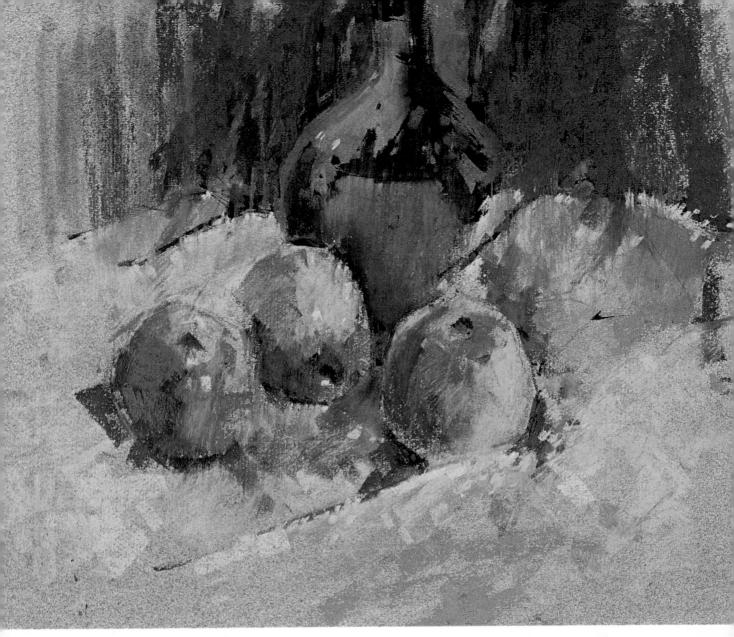

pale blue cloth. I decided to paint a horizontal picture, to give a sense of space around the group, and I chose a fairly light paper, Tumba Ingres Purple Grey, a lot of which I left showing in the final painting – sometimes in large, uncovered areas, or breaking through lightly applied pastel.

First stage Apart from this change to a horizontal format, I kept the positioning of the apples and bottles generally the same as in the sketch. My first step was to draw some guiding lines for the shapes of the apples and the bottle with charcoal. I drew these lines with positive, firm strokes. Although we might think of the apples and bottle as spherical shapes, notice that I made the lines short, straight and angular because of my feeling for the subject and the medium I chose. I felt the angularity of the drawing gave character to the apples and was in keeping with the direct strokes of the pastel. I started to make a few trial pastel strokes. I used Green Grey Tint 4 for the background, Sap Green Tints 1 and 5 for the apples and Indigo Tints 1 and 3 for the cloth.

Second stage I continued to apply these colours, progressively pressing them more firmly into the painting, always working in short, angular directions. I was careful to keep the pale Sap Green clean and unsmudged, because I wanted it to sparkle as reflected light. I sharpened the edges of the dark tones on the bottle and added Raw Umber Tint I and Madder Brown Tint 6 to the label. I blended a few pastel strokes together, by gently rubbing with my finger.

Finished stage I continued to build up the features with the same colours and intensified some of the shadows under the apples and the bright highlights on the apples. I then added a few important finishing touches. I suggested a feeling of dazzling light reflecting from the apple surfaces by flicking bright strokes of pale Sap Green in vertical strokes over the apples. These strokes broke up the surface and the edges of the apples to create crisp flickers of light.

ROADSIDE TREES

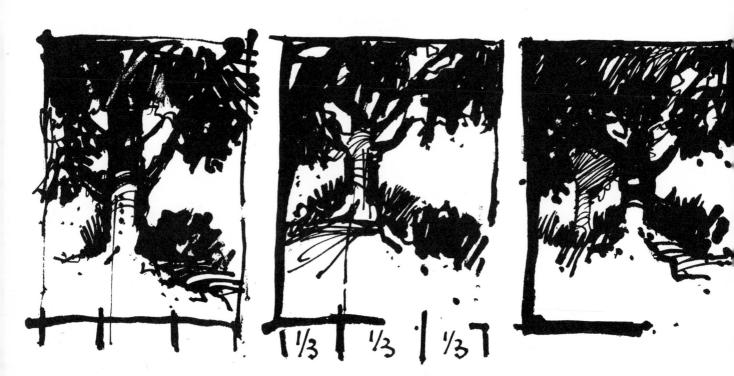

I was attracted by the large mass of this tree and made several thumb-nail sketches of possible compositions. These are very quick sketches to help work out an interesting pattern of light and dark shapes. I stopped thinking about it as a tree for a few moments and I looked upon it as a shape, mostly dark, which I had to fit into a rectangular piece of paper to create an interesting pattern. At this stage I didn't want to get involved with the details of the tree bark and foliage; I was concerned with deciding on an agreeable pattern.

My first reaction was to disobey the accepted rule of not placing the principal feature in the centre of the picture. This rule is to place the feature at the one-third position indicated in two of my sketches. I think any one of these arrangements would be acceptable; they all have a pattern of light and dark shapes, agreeably varied in size. Even so, some determined part of my make-up urged me to stick to my first reaction and place the tree exactly in the middle. It is exciting to break the rules now and then, with perhaps the additional reward of a more exciting or imaginative result. I tried out a little sketch with the tree in the middle, just to confirm my feeling, and I realized that the more distant tree to the left was helping to pull the weight of the painting away from the centre, so perhaps I was not too naughty after all.

First stage I chose a fairly dark paper, Fabriano Mid Grey, and with charcoal drew the outline of the tree trunk and its branches. I drew the lower outline where the big foliage mass met the sky with crisp, rectangular shapes, not gentle curves. Because I thought about the subject as being strong and positive, I drew it with angular lines.

I would like to emphasize to you that I chose pastel for this painting because of its direct nature. I planned to apply the pastel with decisive slabs of colour, so I adjusted my drawing accordingly. My initial thinking, the drawing and the way of applying the pastel were all related. It will help you to infuse a personal quality into your work if you can pin down your attitude to the subject in this way. Try drawing a tree shape with direct, angular lines, and this will help you to apply your pastel with conviction.

I was then ready to register the first pastel strokes. I squinted at the tree with my eyes almost closed, and was aware only of the big mass of tree against the light sky. I quickly pastelled in the sky with strokes of Coeruleum Tint o, Vermilion Tint o and a few strokes of Raw Sienna Tint I, leaving the colour of the paper to represent the tree. I added a few strokes of Raw Sienna and Green Grey Tint I to the foliage.

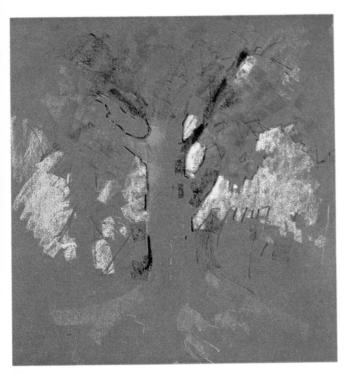

First stage

Second stage I added a little more pastel to the sky, repeating the colours already used, and added a few dark strokes of Vandyke Brown Tint 8 to the bushes behind the tree. I repeated some of this Vandyke Brown in the branches of the tree and used Grey Green for the lighter foliage and Olive Green Tint 7 for the darker parts. I kept all the pastel strokes direct, making no attempt to blend them together. My aim at this stage was to feel my way into the painting, working all over the paper, keeping the painting progressing as a whole. Any corrections that might be necessary are easier if the pastel is not overworked.

Third stage I really started to press the colour into the paper, sliding the side of the pastel along the paper in random directions. Sometimes, the strokes were placed side by side, and sometimes they overlapped. I pastelled the sky with firm strokes around the foliage shapes - the edges of the foliage firmed up as interesting shapes. Using the same greens as before, I continued to press the pastel into the paper to make very strong darks. Occasionally, I blended the greens together by rubbing with my finger. This was a very discreet operation, where I placed my finger on the pastel and gently blended it into its neighbour. I added further touches of Raw Sienna to the trunk and branches and introduced a little Purple Grey Tint 2 into the tree, foreground and bushes. I thought the drawing could be emphasized a little, so I used the end of Vandyke Brown Tint 8 to add some free drawing to the trunk and the branches.

Second stage

Finished stage Until then I had hardly touched the foreground, and I debated what colour to make it. Did I paint it the green that I actually saw, or could I make an adjustment to suit the painting? I decided that the painting already contained a lot of green and some change was desirable. I could have used very cool greens, or even the pale mauve we sometimes see when blades of grass bend over and reflect the sky. I could also have repeated a colour that I had already used in the painting. The light part of the trunk was Raw Sienna, so I decided to use this colour for the foreground, with a few strokes of cool grey and green touched in so the overall colouring was not too different from the actual subject. It just meant I was making an adjustment to suit the painting.

Inexperienced painters should be careful because alterations can lead to inconsistencies. I have seen paintings with shadows falling in different directions because the artist has 'borrowed' a feature from another part of the landscape. I have actually seen a tree moved to another part of the painting and its shadow left in its original position. It is better to think in terms of subduing a feature rather than placing it somewhere else. In this painting, I was merely qualifying the green foreground with Raw Sienna.

Notice that in making the change I chose a colour I had already used in the painting. If I kept adding new colours the painting would have been busy and jumpy. I chose a small area of existing colour, a minority colour in the painting, and repeated it in the foreground. The small area of Raw Sienna in the tree trunk then read as an echo of the

Third stage

larger foreground area. This is an idea for you: echoes of colour are useful. The viewer's eye travels over the painting, picks up these small repeats of colour, pauses to look at them, and then travels on again. The pause is momentary, but enough to involve the viewer.

In the final stage of the painting, I could suggest other such incidents to keep the interest going. The trunk on the left was still just the colour of the paper. I continued the Vandyke Brown of the bushes into the trunk to make it darker and give it a very hard edge, contrasting with the light sky. This hard edge provided another little incident on which the eye could rest. I was careful not to overdo it and softened the upper part of the trunk by lightly dragging the colour at the edges. This process of changing from a hard to a soft edge is often referred to as 'losing and finding' the edges. I also used this process in the foliage, where I silhouetted some edges crisply against the sky and then softened them again.

The branch in the upper right corner of the painting was painted as a precise detail, to catch and hold the eye. It is a thick, solid, black line which emerges from the mass of foliage and is silhouetted sharply against the sky, before losing itself again in the foliage. Small areas of intense contrast such as this will momentarily hold the attention of the viewer and I like to design them into my paintings.

All I then had to do was strengthen the painting by adding pastel with increased pressure to various parts – merely building up the pastel I had already applied.

I said at the beginning that I was attracted by the large mass of the tree. This interest was achieved by using a strong tonal range, with very dark tints in the foliage contrasted with a pale sky. I also emphasized the dark tones of the tree by making the foliage bigger than the light sky. The contrast of dark and light was emphasized by puncturing the foliage to show small, intense bits of sky.

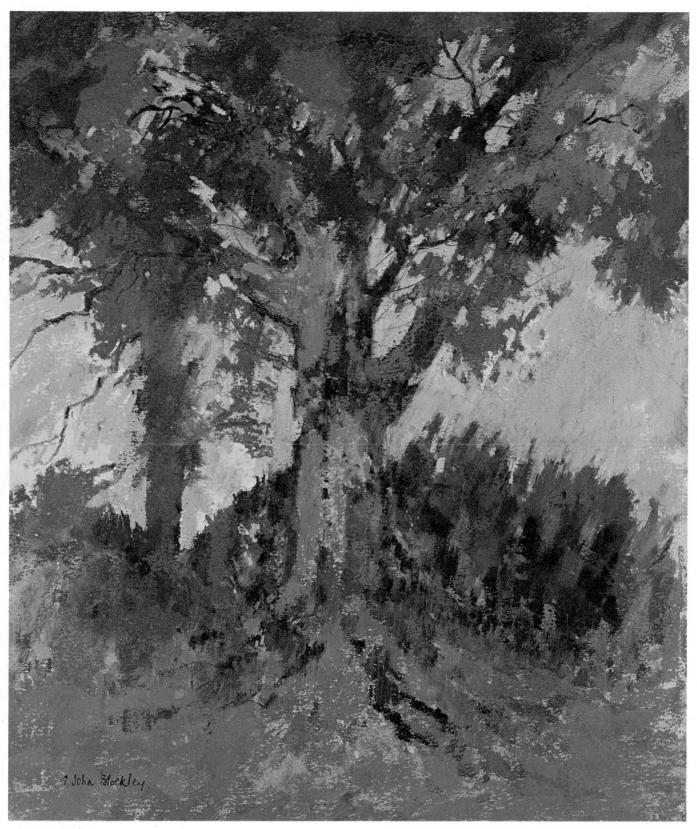

Finished stage

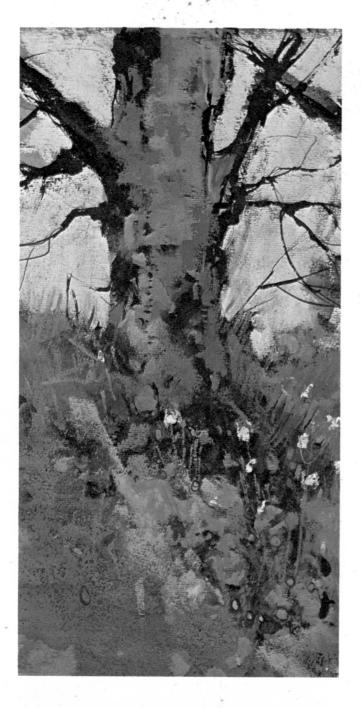

TREES

Trees are a fascinating subject for a painting. These three were part of a row standing along the top of a grassy bank. I liked the pattern they made with the sky showing between them, and was intrigued by the mottled surfaces everywhere. The tree trunks were blotched with black, grey and tints of bronze and the pattern seemed to continue into the bank, with its patches of grass growing between stones and eroded soil. The painting is about the decorative surfaces and I thought in terms of a mosaic of echoing shapes and colours.

This sort of thinking plays a great part in my own painting and you should consider similar ideas yourself. Look for an interesting characteristic of a subject and influence your painting towards it. In this painting the interest was obvious; even the sky spaces between the branches were roughly similar in shape to the patterns in the tree trunks and ground.

I sketched the outline of the trees with charcoal on Stone Grey Fabriano Ingres paper and immediately cross-hatched the sky, temporarily leaving the paper to represent the tree trunks and branches. For the sky, I used Coeruleum Tint o, with hints of Indian Red Tint o. I hatched the lines close together so the sky was almost unbroken colour, as I wanted to confine texture to the trees and ground.

I then had a piece of grey paper with the light shapes of the sky on it and I started to register the general pattern of the mid-tones. With the side of Warm Grey Tint 3 I drew bands of colour, in various directions, over the foreground. This pastel was slightly warmer and a little darker than the grey paper and by dragging it lightly over the paper I was gradually able to indicate a pattern all over the foreground. I then added firmer strokes of the same pastel and some darker tints of it. Occasionally, I softened an edge with my finger and left round and oval shapes of the paper uncovered. I outlined a few of the rounded shapes with the end of a Sepia pastel. I continued this process, adding tints of Autumn Brown pastel as I worked the pattern into the trees.

Finally, I pressed strokes of Sepia Tint 8 into the paper to arrive at the very dark passages. Don't be frightened about painting such strong darks. They are important in this painting to emphasize the pattern. I also used the end of this pastel to draw the finer branches.

I followed the same procedure to paint the single tree study. I enjoy picking out a single motif such as this, and painting a small, intimate picture.

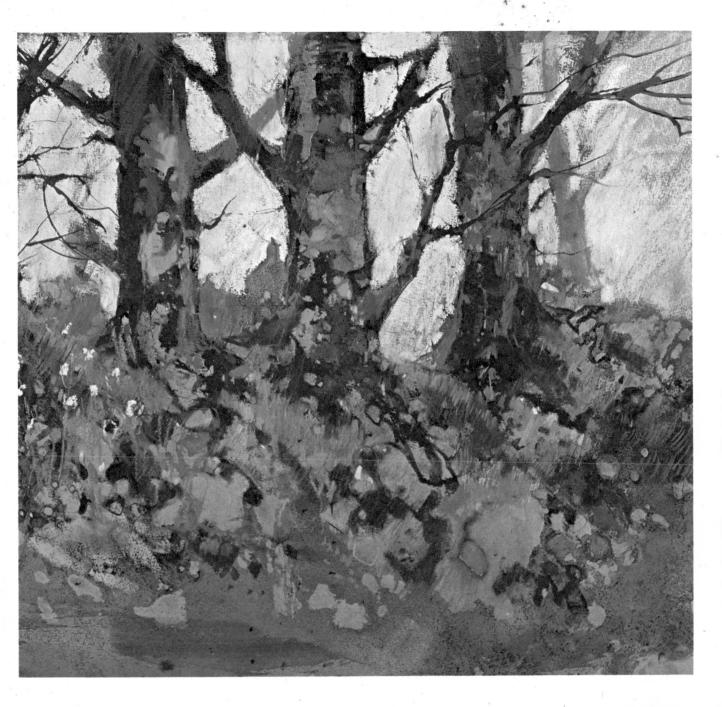

COTSWOLD LANDSCAPE

This landscape is typical of the upland countryside surrounding my studio; big and open with wonderful skies. I love to go up there, especially in the early morning or evening when the quality of light seems to bring out the colours of the landscape. In this painting, I wanted to record the storm clouds building up, and even as I looked, local rain slanted down to break the distant skyline. The sky was dark indigo at the top and lightened towards the skyline with broken paler blue, almost green, with a hint of pale cream here and there. The lighter clouds seemed to glint with light against the sombre indigo, and I immediately felt the effect could best be described with short, staccato strokes of pastel, applied crisply and unrubbed.

The colours of the dark clouds were echoed in the long sweeps of the distant hills, and in other parts the normally brown soil of the landscape was modified by the grey clouds to bands of dark purple-brown. These low-toned sweeps of colour were relieved by hard-edged slices of brighter colour, almost pink. I asked myself what pastel colour I should use for this, and thought of a lighter tint of Purple Brown. When you have experience of looking at the landscape and painting it, you will find yourself thinking in terms of pastel colours at all times, not only when you are painting.

First stage I chose Deep Stone Ingres Fabriano paper, because it seemed to match the middle tones of the land-scape, and I drew a few lines with charcoal to register the main shapes and contours of the landscape. These are the black lines in the illustration. I did not draw the precise shape of each field because there was a danger of painting in a detailed way, filling each individual shape, as if I were 'painting by number'. I wanted to apply the pastel in sweeping motions to suggest the long undulations of the landscape, so I drew only a few guiding lines. The profile of the tree was drawn with straight, angular lines.

For this demonstration I pressed the charcoal on to the paper much stronger than I normally do; I only need the faintest guiding line. I had to remember to dust the line drawing down by flicking it with a rag before going on to the next stage because I didn't want the black outline to show in the final painting. I lightly indicated the outline of the clouds with white pastel to establish the cloud pattern. Clouds will constantly change, but it is impossible to keep changing the painting, so we have to register an interesting pattern and stick to it.

The work so far had consisted of drawing lines with the end of a piece of charcoal or pastel. I then started to use the side of the pastel to drag bands of colour on to the paper. I registered the light tones of the sky with Silver White

and a few mid-tones with Blue Grey Tint 2. I indicated the lighter green of the tree with Olive Green Tint 4 and the darker green with Tint 7. The brief bands of light across the landscape were made with Raw Sienna Tint 1. At this stage, I was just beginning to feel my way into the painting, so I kept the pastel strokes simple, tending to stroke them all in the same direction. I was careful not to concentrate on any particular part of the painting, and instead I aimed at covering most of the paper with open pastel strokes. As the painting proceeded, I filled in the spaces and built up the layers of pastel.

Second stage The pastel had been applied with positive strokes, but only light pressure. I continued to expand these colour strokes, using firmer pressure on the pastel, to cover more of the paper. I kept checking in my mind that the colours looked right. Gradually building up to the final intensity of pastel is a good way to work; although mistakes can be removed with a brush I think it is good discipline not to rely on correction.

I pastelled long strokes of Purple Brown Tints 1 and 6 and Green Grey Tint 1 across the foreground.

Third stage I stopped and had a good look at the painting and even walked away from it for a few minutes. This little break is enough for the eye to look at the painting again, with a fresh appraisal, and errors not previously noticed often become obvious. I asked myself if I was satisfied with the pattern of shapes and relationship of colours that were firming up on the paper. My interest was mainly with the sky, so I checked that I was sticking to this in the painting. Were there any bright parts in the landscape that attracted attention away from the sky? Yes! The pink to the right of the tree was too bright and must be subdued. How could I have done this? I could have smudged it into the grey paper with my finger, but that would have led to an indecisive quality in the painting. I could have dusted it down with a stiff brush and applied new pastel of a slightly darker tone. I decided that as the pastel had been put on the paper fairly gently I could safely apply another quick layer of a darker tone without making it smudged and overworked. I thought that when I did this the colours in the landscape would be sufficiently subdued in relation to the sky.

Then I took a hard look at the sky. I decided the pattern of the clouds was sufficiently interesting, with each light cloud almost echoing the shape of its neighbour, and all of them sloping in one direction. Notice my pastel strokes in the clouds; although the clouds themselves slope down to the right, the pastel strokes within them slope down to

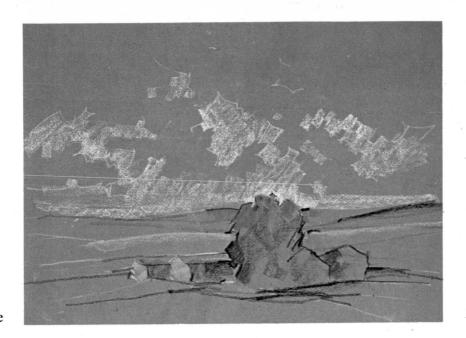

First stage

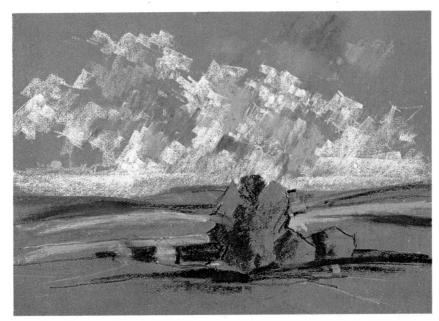

Second stage

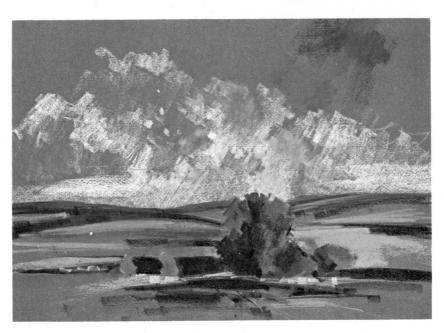

Third stage

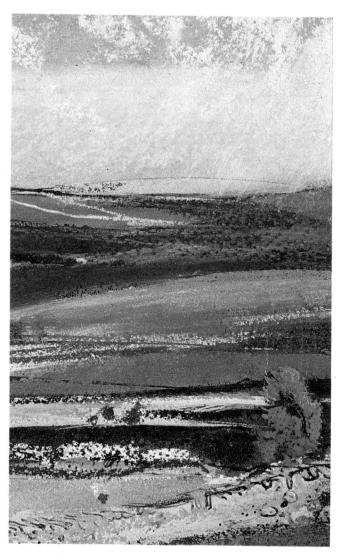

the left. This was a deliberate ploy to counteract the movement of the clouds, sliding out of the picture. The opposition of movement also created some agitation in the sky which helped my wish to draw attention to the sky. I would also like you to notice that the shape of the pastel strokes contributed to the general liveliness of the sky. They are short, quickly-applied slabs of colour; almost jerky and abrupt. I quietened this feeling of movement here and there by overlapping some of the pastel strokes so their edges blended, but did not rub them with my finger.

This was an important stage of the painting, where I looked critically at its progress. As I decided each part was satisfactory, I built up the pastel with firmer strokes.

Finished stage I completed the sky by adding Indigo Tint 3 along the top and pressing in short strokes of Coeruleum Tint 0 to create the greenish-blue pale lights in the white clouds. I strengthened the darks of the landscape with further strokes of Purple Brown and Green Grey. I made some strokes crisp and edgy and allowed others to blend together and soften.

Throughout the painting, I kept in mind my original interest in the sky. I registered the glints of light with crisp flicks of pale pastel and contrasted these with darker greys and blues, sometimes smoothed into atmospheric qualities by gently rubbing with my finger. Having decided at the beginning this was the best treatment for the sky, I stuck to this decision, and limited this treatment to the sky. The landscape was painted entirely with long strokes of pastel, which accentuated the short slabs of pastel in the sky, and also explained the gentle undulations of the landscape.

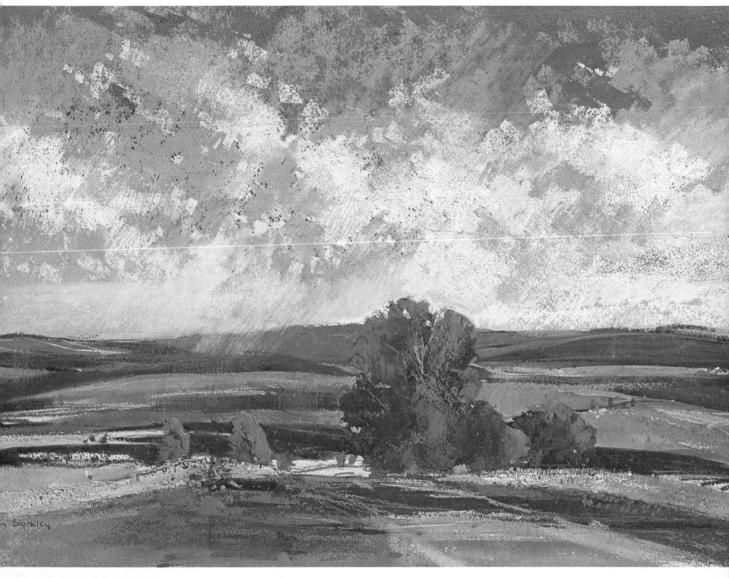

Here and there, I allowed some light passages across the landscape, but mainly kept the colours fairly sombre so the light was concentrated in the sky.

I also employed smoother strokes in the ground by occasionally rubbing with very slight finger pressure. In contrast, I left the sky unrubbed, in thick layers so the pastel granules clung to the paper surface and reflected the light. I really meant that I wanted the sky to have layers of pastel, so I helped this by fixing each pastel application by spraying it with fixative and pastelling over it. I repeated this at various stages of the sky and left only the final layer unfixed, which gave a shimmering quality to the light parts of the sky.

When painting, I always ask myself questions before each stroke. 'Is this pastel colour light enough, or dark enough; is it the correct tint; is it correct in terms of my main interest, will it support my interest in the sky or will it compete with it?'

You should always try to decide what particular aspect of the subject interests you before starting to paint, and keep this in mind as I do by asking yourself questions throughout the painting.

FIXING PASTELS

It seems appropriate to finish the book by showing you two ways of fixing pastels. Here I am fixing one of the intermediate layers of Cotswold Landscape, and Low Water when it was finished.

For Cotswold Landscape I used a diffuser, with one leg of the spray dipped into fixative. I blew into the plastic mouthpiece end and the fixative was sprayed on the painting. The other method, which I prefer, is to spray from an aerosol canister of Perfix.

LEARN TO PAINT WITH PASTELS JOHN BLOCKLEYR

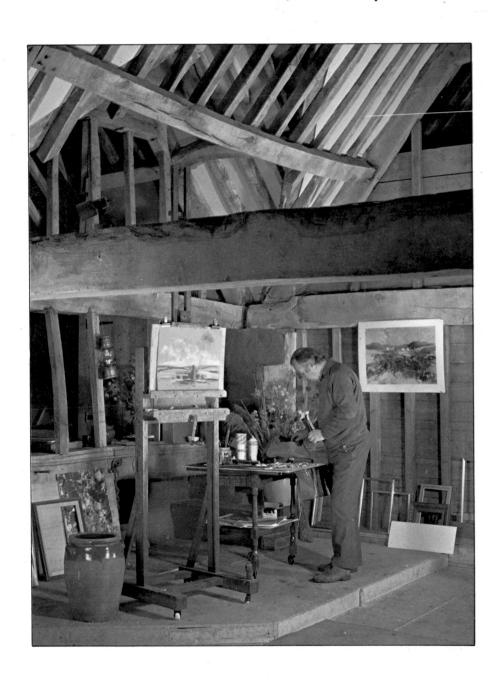

COLLINS GLASGOW& LONDON

Industrial Town, Late Evening
Industrial towns often provide unusual conditions to paint. Here, the sky is turned orange by the evening light filtering through the industrial haze

First published 1980 Reprinted 1982, 1983, 1984 Collins Publishers, Glasgow and London

© John Blockley 1980

Designed and edited by Youé and Spooner Limited Filmset by Tradespools Limited Photography by Michael Petts

ISBN 0 00 138302 7

Printed in Spain by Graficas Reunidas, S.A.

Rowney pastels were used for all the paintings illustrated in this book. John Blockley uses these pastels for all his paintings and finds their consistency and quality incomparable.